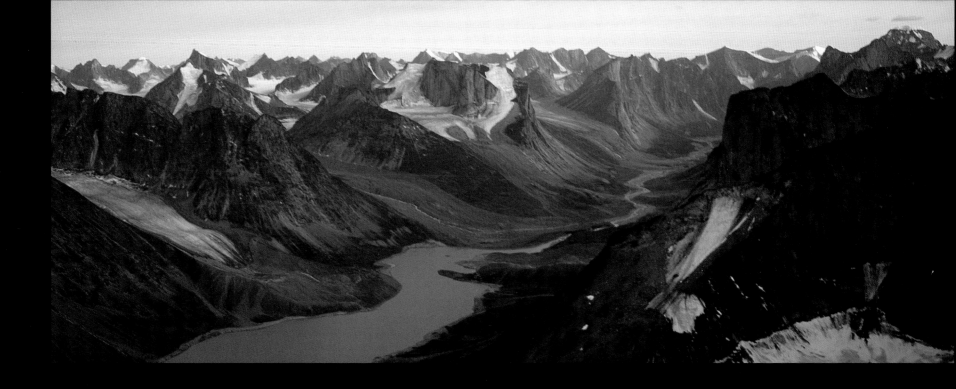

ALASTAIR LEE

FRANCES LINCOLN LIMITED

PUBLISHERS

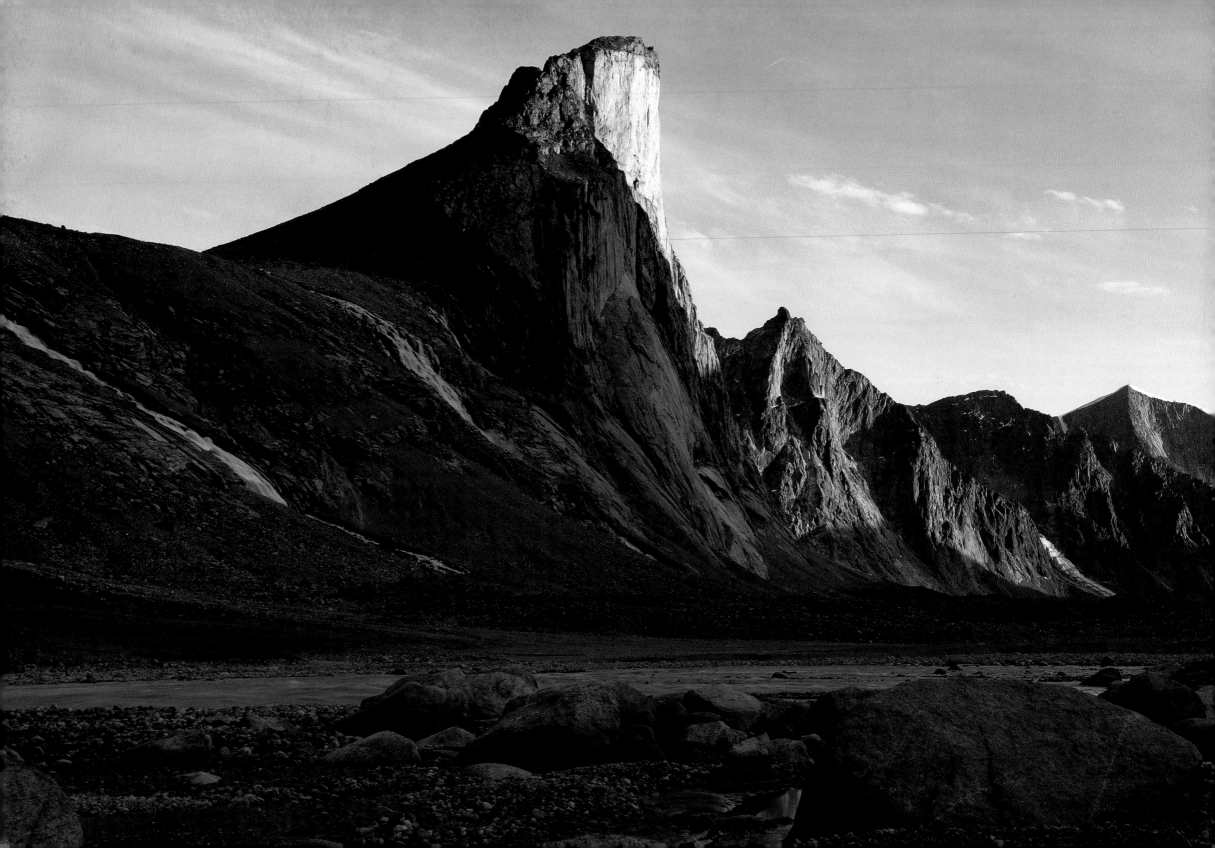

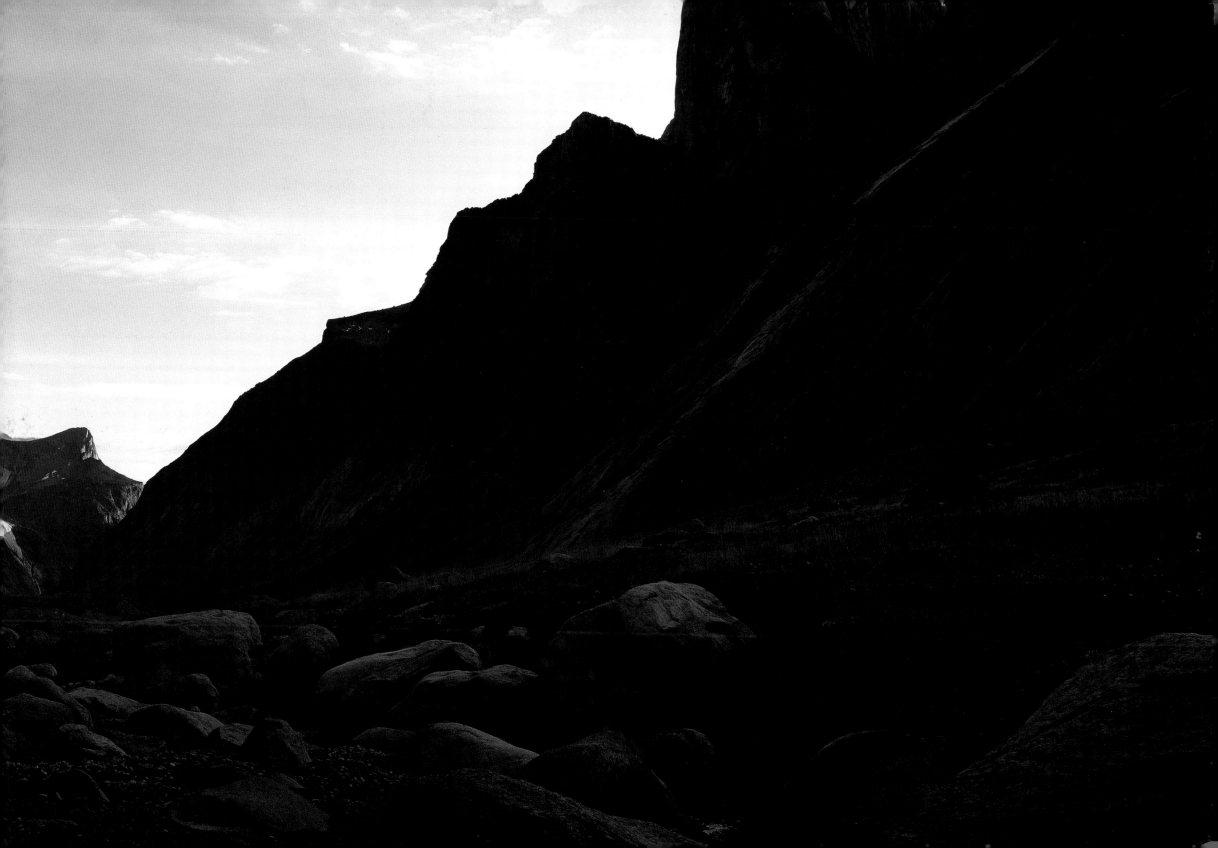

Frances Lincoln Limited
4 Torriano Mews
Torriano Avenue
London NW5 2RZ
www.franceslincoln.com

Baffin Island: The Ascent of Mount Asgard
Copyright © Frances Lincoln Limited 2011
Text and photographs copyright © Alastair Lee 2011
Design, layout and repro by Alastair Lee
Additional text and layout Ian Burton
Editing and proofing by Colin Wells
www.alastairleephotography.co.uk
www.posingproductions.com

First Frances Lincoln edition 2011

British Library Cataloguing in Publication Data.
A catalogue record for this book is available from the British Library.

978-0-7112-3221-1

Printed in China

9 8 7 6 5 4 3 2 1

THIS PAGE - The cylindrical and triangular silhouettes of Mount Asgard and Mount Loki respectively. Photo Ian Burton.
PREVIOUS PAGES - The impressive Mount Thor in the Weasel Valley. TITLE PAGE - Peaks and big walls abound in the remarkable
Baffin landscape, aerial photograph. OVERLEAF - The author filming from a DC-3 flight over Mount Asgard. Photo Leo Houlding.

CONTENTS

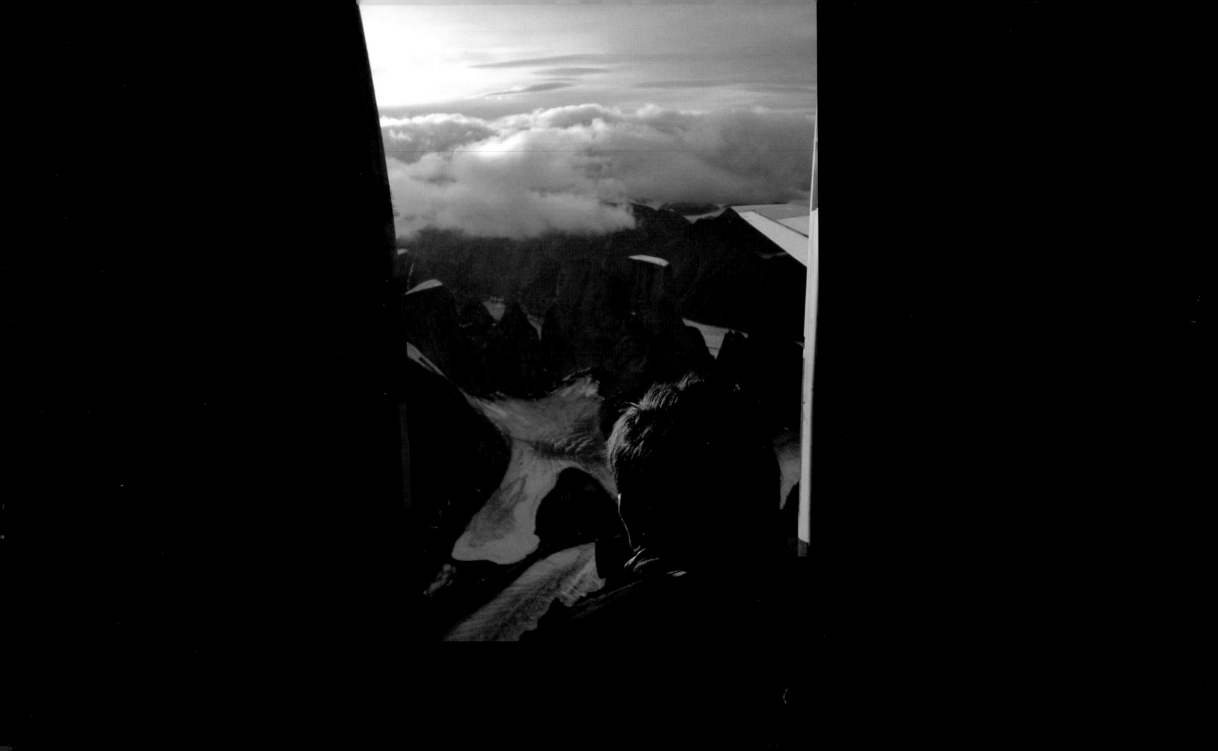

INTRODUCTION

Baffin Island, the fifth largest island in the world, constitutes an enormous territory of a truly wild and extraordinary nature. There are countless wonders in its culture, history, wildlife and remarkable landscape; almost too many, in fact, to absorb or to document in full. Any book which attempted to cover just one of these topics comprehensively would be making a bold claim and would certainly require many years of effort. So while this book is titled *Baffin Island* it should be made clear that its content stems from the experience of one extended visit to the island – it is certainly not an attempt to present Baffin Island in an authoritative manner. Instead, it focuses on an expedition to climb the island's most striking mountain; Mount Asgard. The landscape that the team encountered on the lengthy approach to the mountain and the fortress that is Asgard itself is so striking and unique, it seemed an excellent opportunity to share the images we captured with a broader audience beyond the climbing and mountaineering world.

In essence, this book covers a select area of Baffin Island; a part which nevertheless arguably contains the island's most spectacular landscapes. The pictures presented here, all of which were taken during a six-week expedition that began in late July 2009, together with dramatic action shots relating to the story of the ascent of Asgard itself, are intended to celebrate this unique country. I have therefore selected the best pictures captured during the expedition which I hope demonstrate that it is not necessary to be a mountaineer to appreciate this extraordinary part of the world. So whether you are a climber, armchair adventurer or simply an inquisitive art book collector, I hope that you will be impelled to turn the page, to marvel and wonder at one of the world's less-frequented but most spellbinding landscapes.

In its modest way, I also hope this book may help raise awareness of this savagely beautiful land. So much of the Arctic is now imperilled by climate change and mineral prospecting that I hope the book serves to echo the sentiments of the great wilderness conservationist John Muir: 'In order to preserve these great wonders we must first show they are there.'

LEFT - Baffin Island located in north-east Canada, the world's fifth largest island. Mount Asgard located. RIGHT - Map locating Mount Asgard and other important peaks mentioned or present in this book. The Akshayuk Pass, an ancient travel corridor used by the Inuit for thousands of years is clearly visible running from north to south. OVERLEAF - Southern entrance to Auyuittuq National Park; mouth of the Weasel River and Mount Overlord, taken en route from the township of Pangnirtung in Pangnirtung Fjord. We took a lift up the 30-kilometre fjord in a fishing boat driven by our local outfitter, Charlie. This was the last time we would be travelling so fast until the boat returned to pick us up six weeks later.

PENNY ICECAP

MOUNT BRYNHILD

MOUNT SVANHVIT

MOUNT LOKI MOUNT ALVIT

OWL VALLEY

MOUNT ASGARD

MOUNT MIDGARD MOUNT FRIGGA

MOUNT FREYA

SUMMIT LAKE

MOUNT TYR

MOUNT BALDR

MOUNT ODIN MOUNT THOR

WEASEL VALLEY

MOUNT SIF

PANGNIRTUNG FJORD

MOUNT OVERLORD

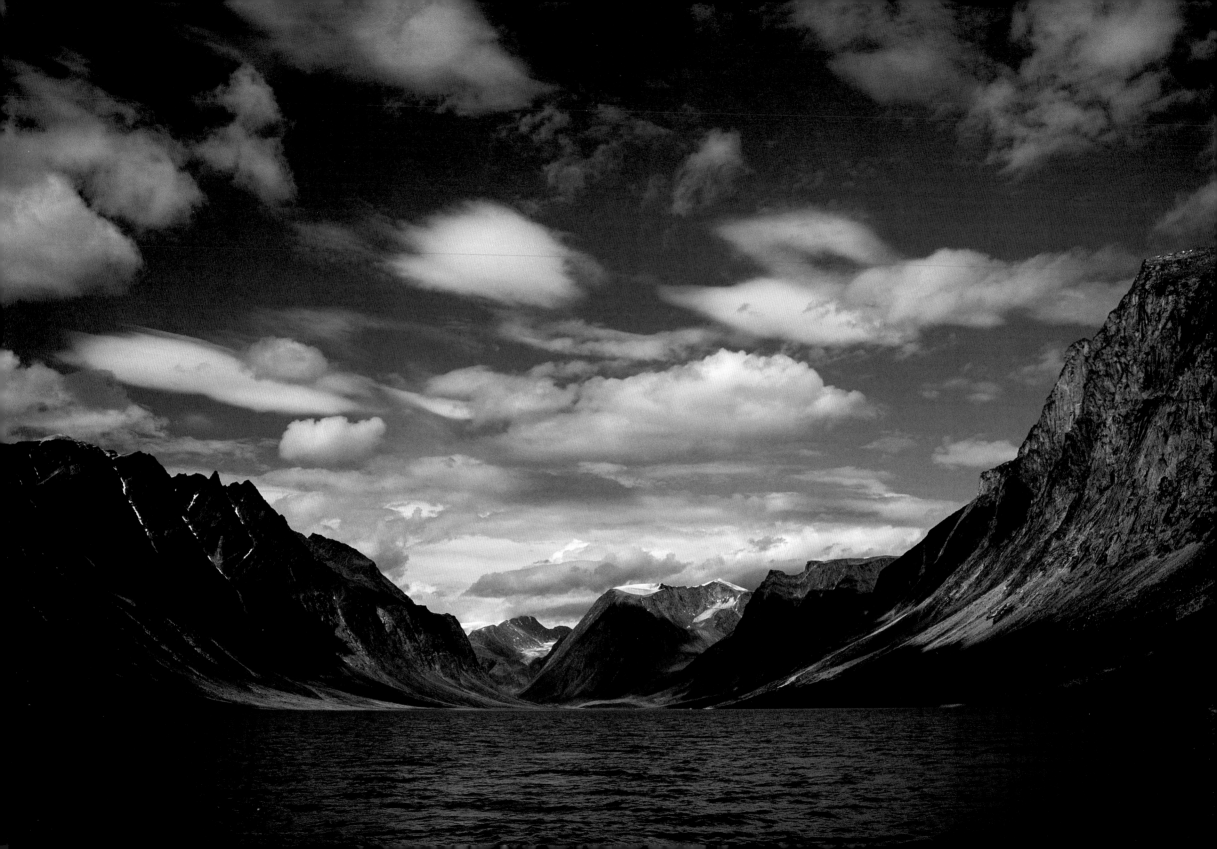

1
GATEWAY

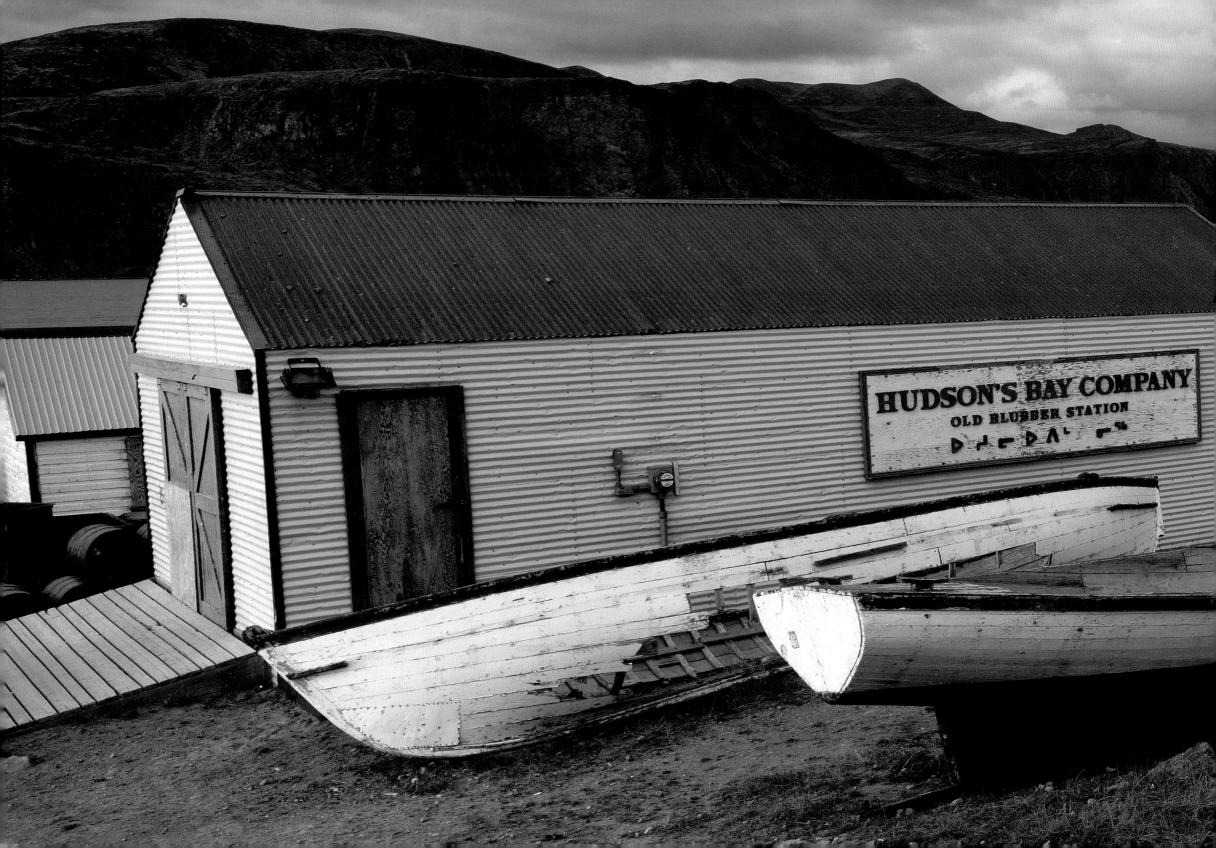

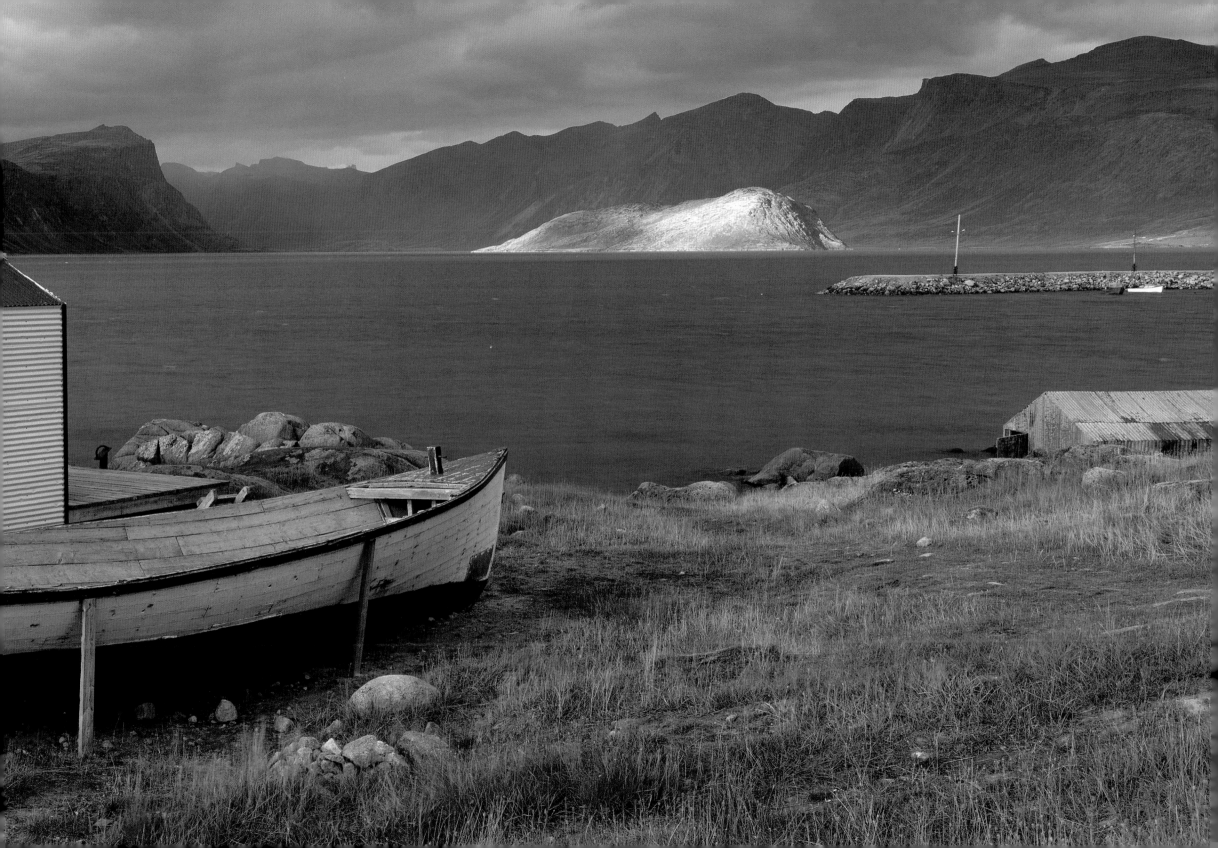

Auyuittuq: The Land That Never Melts . . .

It was foot power from now on, crossing the Arctic Circle Inukshuk and up to a natural turning point onto the Turner Glacier at the end of Summit Lake, four to five days away. The walk is easy enough – if you discount the 35-kilogram packs, endless sand dunes, quicksand and mountains of shifting moraine, not to mention the cripplingly cold river crossings.

THE AUYUITTUQ NATIONAL PARK

Sweeping glaciers and polar sea ice meet jagged granite mountains in Canada's Auyuittuq National Park. Established in 1976, Auyuittuq – an Inutitut word meaning 'land that never melts' – protects 19,089 square kilometres of glacier-scoured terrain. Located in the eastern Arctic, on southern Baffin Island, the park includes the highest peaks of the Canadian Shield, the Penny Ice Cap, marine shorelines lining coastal fjords, and Akshayuk Pass, an ancient travel corridor used by the Inuit for thousands of years. The park offers numerous and varied possibilities for experiencing the majesty of the Arctic whether it be climbing Auyuittuq's rugged peaks, skiing pristine icefields, or hiking the scenic Akshayuk Pass. We were here to climb Mount Asgard, which meant a journey along most of the Akshayuk Pass.

Wildlife film maker Martha Holmes once wrote, *'Few people travel in polar bear country without a rifle.'* We were those few.

In spite of the rule that you're not allowed to carry a rifle in Auyuittuq National Park, on arriving in Pangnirtung, we were disconcerted to discover the town had run out of the alternative anti-bear deterrents of pepper spray and flares. But on an encouraging note, at least we were a large group; seven people could act as a pretty intimidating challenge, even to a Polar Bear. 'Just don't hang around the head of Pang Fjord' we were told. In the event, we needn't have worried. We weren't to see even a single bear, even though the Park centre's visitor log book recorded their undeniable presence.

The trip began on 1 August 2009. Charlie Qumuatuq, our Inuit outfitter, chatted to us on Pangnirtung's dirt runway. As it was the dog days of Baffin's mid-summer Charlie, clad in only a tee-shirt, was relishing the warm weather. We were also wearing tee-shirts – but under several layers of warm clothes. To us hardy mountaineers, it felt like a chilly British autumn day.

This reflected the fact that Baffin Island occupies the far north east of Canada, straddling the Arctic Circle. Pangnirtung is a true frontier town, with nothing beyond it but mountains and ice caps. In the other direction lies the furthest shores of the developed world, with its mining engineers, SUVs and insatiable demand for raw materials. The locals of Pang' know that the miners are coming – and that it's only a matter of time before their timeless tranquillity is changed forever by money, machinery and alcohol.

The expedition began with high excitement, anticipating what lay ahead. We were, after all, here for adventure, to experience nature at its most pristine, rugged and isolated, hoping to adapt from our urban comforts and habits as we rose to the challenge of inhospitable conditions. While the practical 'objective' of the expedition (to use the time-worn mountaineering term, itself originally borrowed from the military) was simply to climb a mountain, the more perceptive members recognised instinctively that the 'journey' is where the real – some might say, 'spiritual' – rewards lie on an expedition like this. If nothing else we hoped that by recording our visit to this special part of the world we might help to highlight its true value – one which is surely greater than any mere accounts sheet reckoning accruing from prospective mining.

PREVIOUS PAGES - View from the shores of the town of Pangnirtung looking down Pangnirtung Fjord towards the gateway to the Auyuittuq National Park. Photo Ian Burton. LEFT - The head of Pangnirtung Fjord below Mount Overlord; after record-breaking amounts of sunshine in July 2009, our arrival in August coincided with more inclement conditions. BELOW FROM LEFT TO RIGHT - The first emergency shelter along the Akshayuk Pass from the south: these are intended to be used to protect yourself from a Polar Bear and are equipped with radios. - The author, Jason Pickles, Chris Rabone and Ian Burton strike a pose at the Arctic Circle with Mount Odin (Baffin's highest peak) getting in on the act. - Day two of the walk to Mount Asgard – it was time to get moving with our rather large packs.

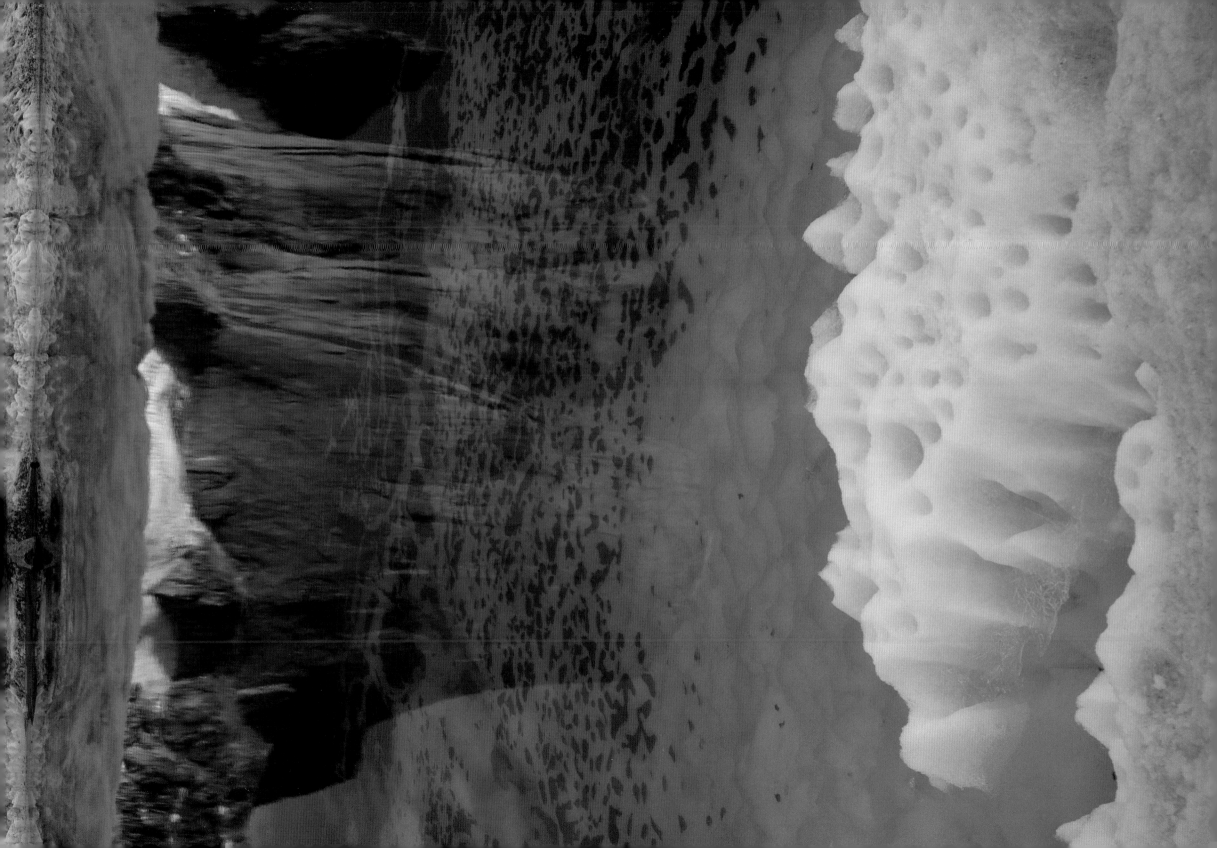

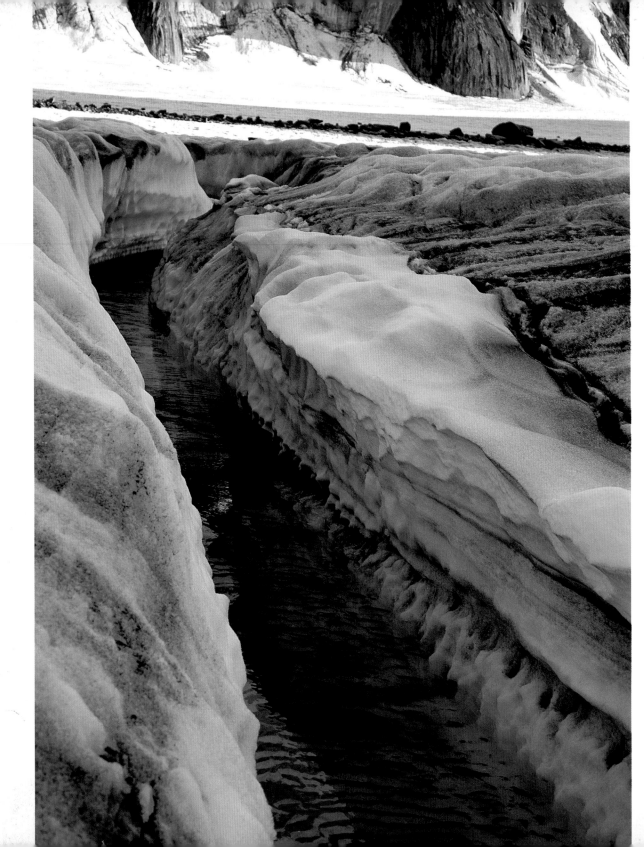

PREVIOUS PAGES - The magnificent twin towers of Mount Asgard reflected in a melt water tarn on the Turner Glacier.

RIGHT - Further evidence that 'the land that never melts' is indeed melting. The Turner Glacier is receding rapidly under the increasingly warm Arctic sun, witnessed by the many glacial streams and mini ice gorges.

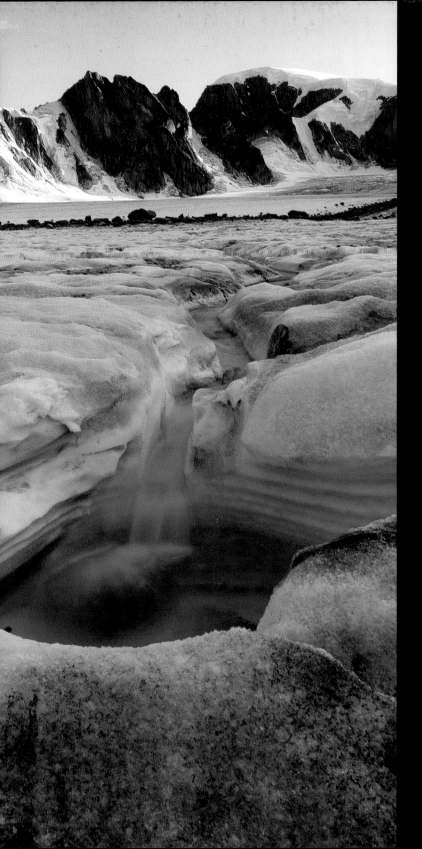

A beautiful glacial pool on the Turner Glacier (a little too cold for a dip however). Shallow streams like this one were common across the glacier in midsummer. One ran directly through our base camp, ideal for washing and cooking. At first the icy waters would be painful on our unconditioned hands. After a week or so we were convinced the water had warmed up, when in fact our skin had just become thicker.

One of the interesting facets of an expedition of this length in such an extreme environment is how you soon adapt to your surroundings. What at first would seem harsh or frightening, soon became the norm.

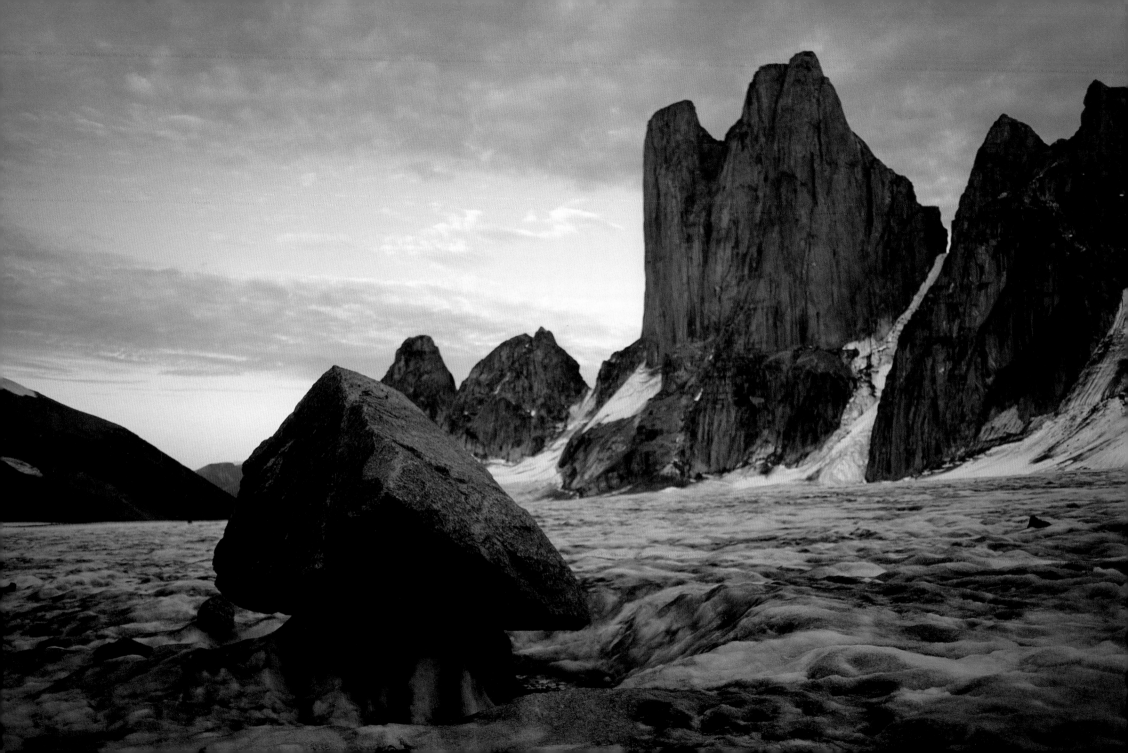

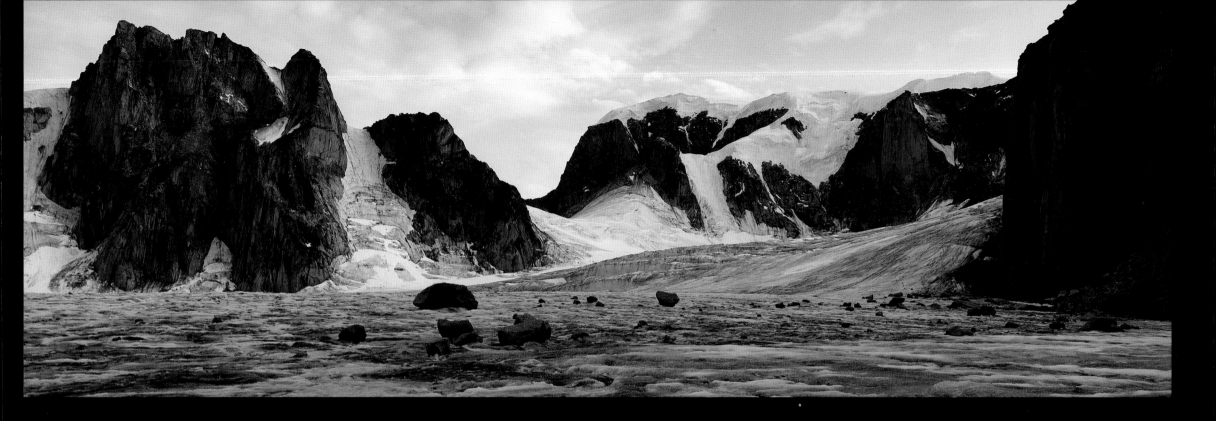

From Norse mythology comes the word 'berserk', meaning 'deranged', 'raging' or 'crazed'. We often encountered chaotic scenes such as these, from the top end of the Turner Glacier, which reminded us of the attributes of Berserk, a legendary Norse hero of the eighth century who always went into battle without armour and was famed for the savagery and reckless fury with which he fought.

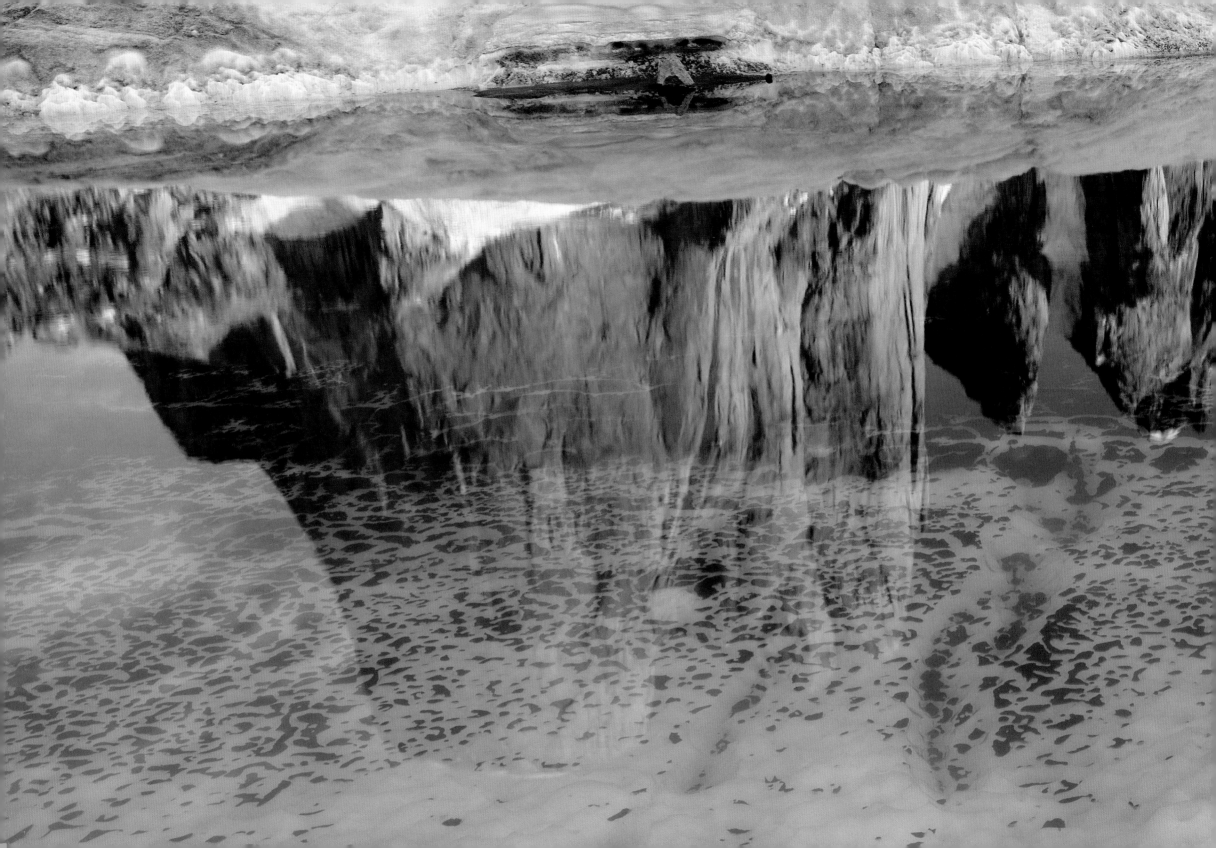

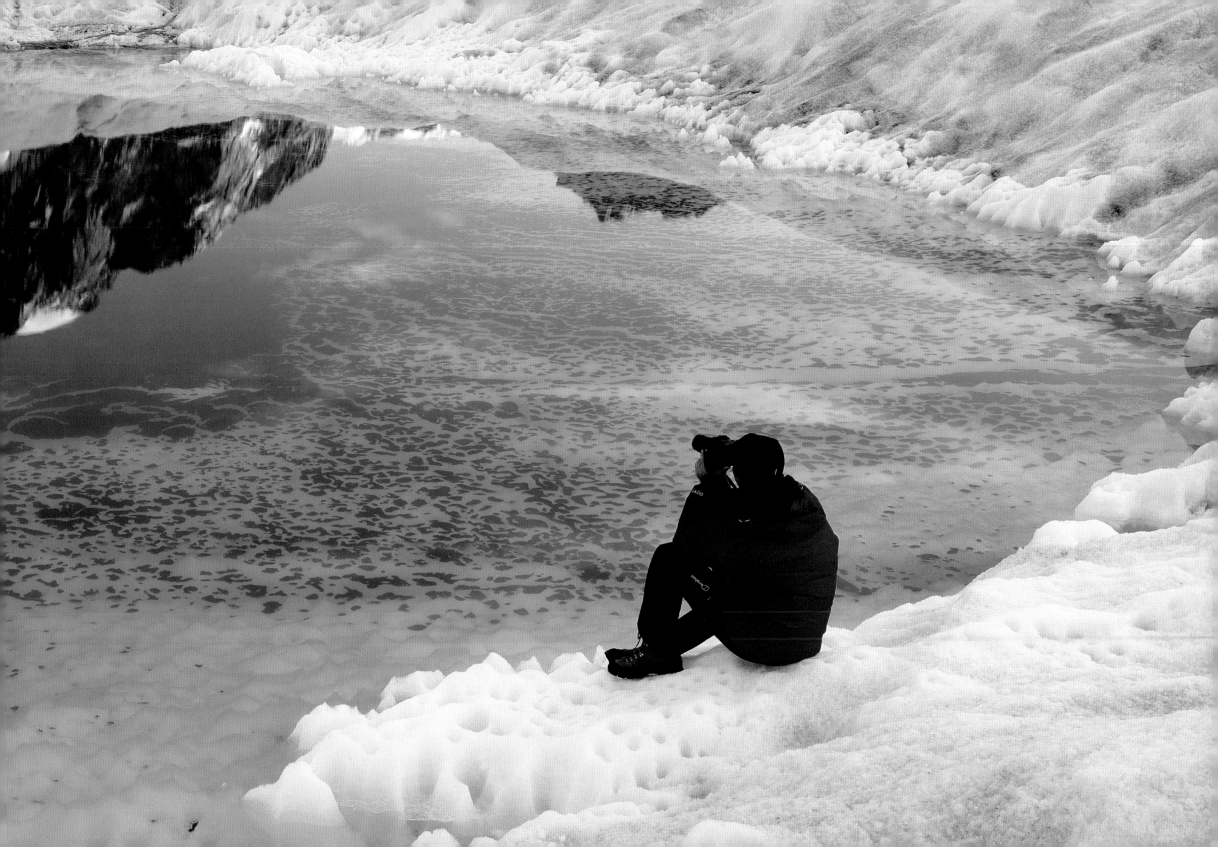

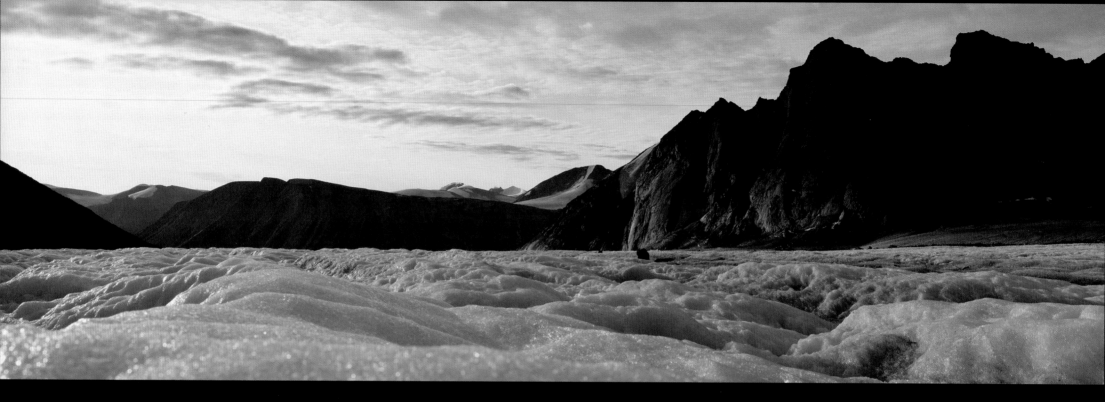

PREVIOUS PAGES - Mount Asgard reflected in a glacial pool on the Turner Glacier, the expedition ground cameraman Ian Burton takes aim.

RIGHT - I woke at 2 a.m. and walked down the glacier to get an angle looking at the north-east face of Mount Asgard, where one of the first routes up the mountain itself goes. The Scott Route by legendary British climber Doug Scott (climbed during an influential expedition of 1972) follows the left-hand profile of the photo on the right. 37 years later and our team (Leo Houlding, Sean Leary, Carlos Suarez, Jason Smith) made a four-hour speed ascent of the route.

ABOVE - The soft Arctic light of 3 a.m. in early August touches the Turner Glacier.

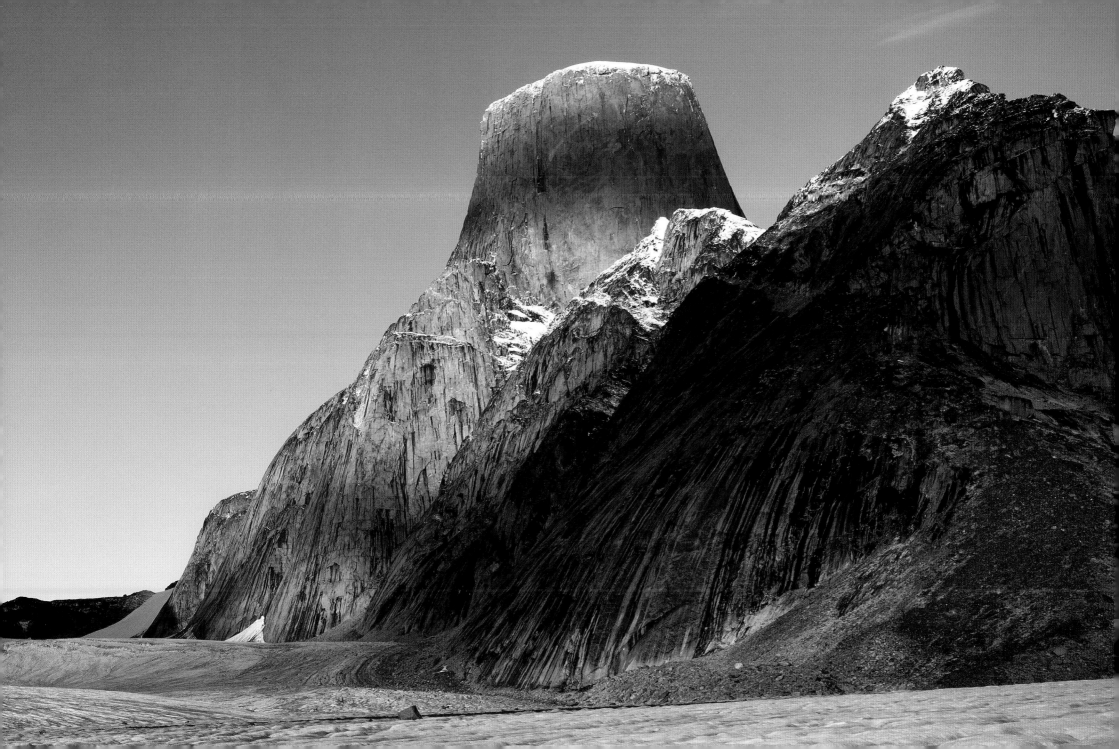

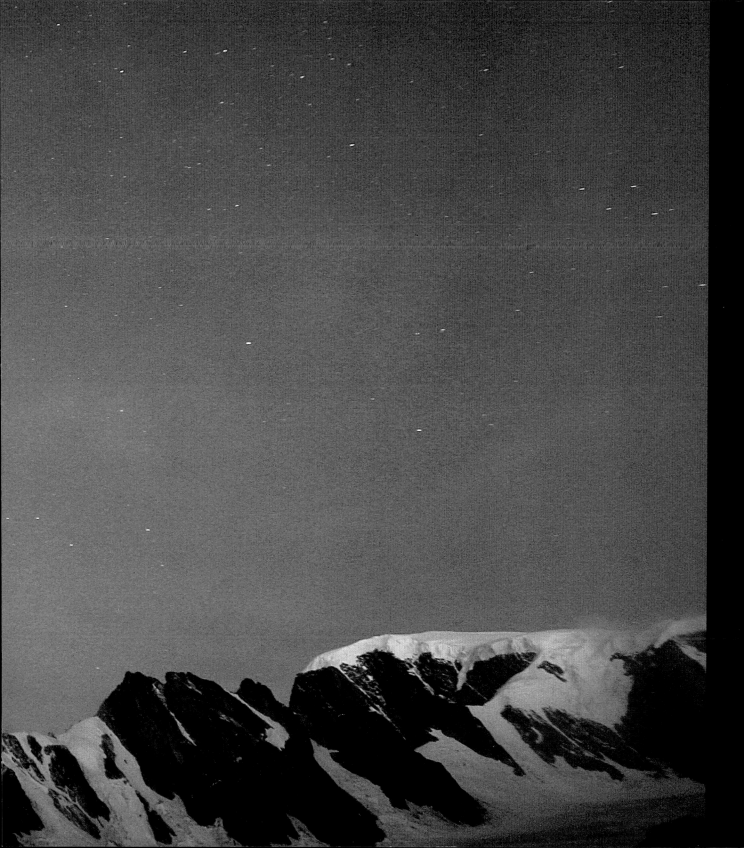

The headlights of the wall team are visible on the north face, while the light trail from a transatlantic jet mimics a shooting star thanks to the long exposure needed to make the photograph. Photo Ian Burton.

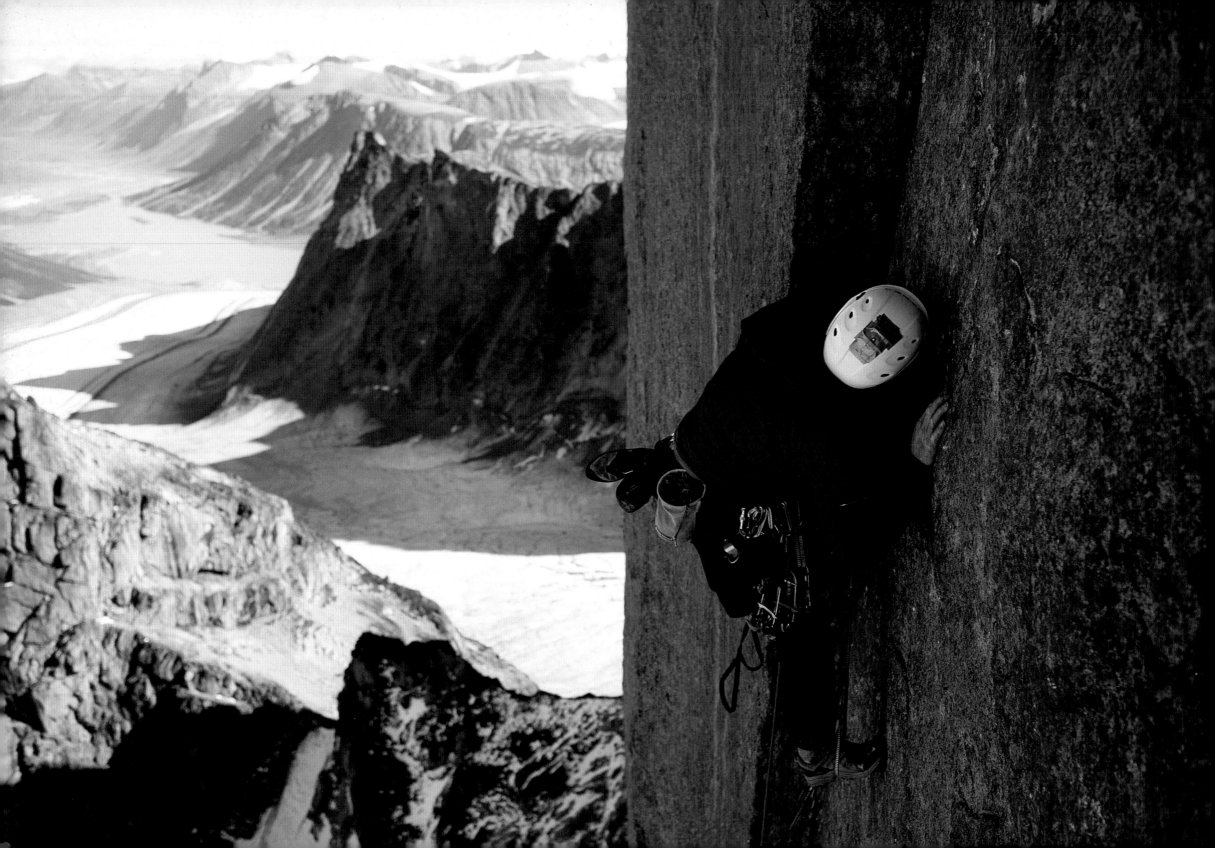

3

THE ASCENT OF MOUNT ASGARD

IN THE LAP OF THE GODS

Climbing on Mount Asgard is a relatively new game, one of the final frontiers of the climbing world. The mountain was first ascended via the back of the north tower in 1953 by a Swiss team which now commonly provides a descent route for the those making climbs on the steeper faces of the two towers. The revered British climber Doug Scott led an expedition to Asgard in 1972 and established his eponymous Scott Route on its north-east face. There are now around 14 routes on the steeper faces of the north and south towers, although none of them have been climbed entirely without the use of artificial aid to overcome blank sections. The particularly forbidding, dark and vertiginous north face has very few free climbing sections on it at all. One of the most notable routes, the Porter Route, was pioneered by American Charlie Porter in 1975 as a solo climb. This was the first modern, multi-day, technical, big-wall climb on Baffin, with 40 pitches rated at a grade of VI, A3+, 5.10. As if this was not arduous enough, it was followed by a 10-day walk out to the fjord-head without food. Charlie was reported to have crawled for the final two days and never climbed again after this epic encounter.

In addition to being the perfect home for Norse gods, the steep and remote location of Asgard is a natural arena in which to stage an epic climbing battle. While the slightly less intimidating adjoining peak of Midgard is for mortals, those that dare to step on to Asgard may soon acquire the uncomfortable feeling that they are being judged by these same gods.

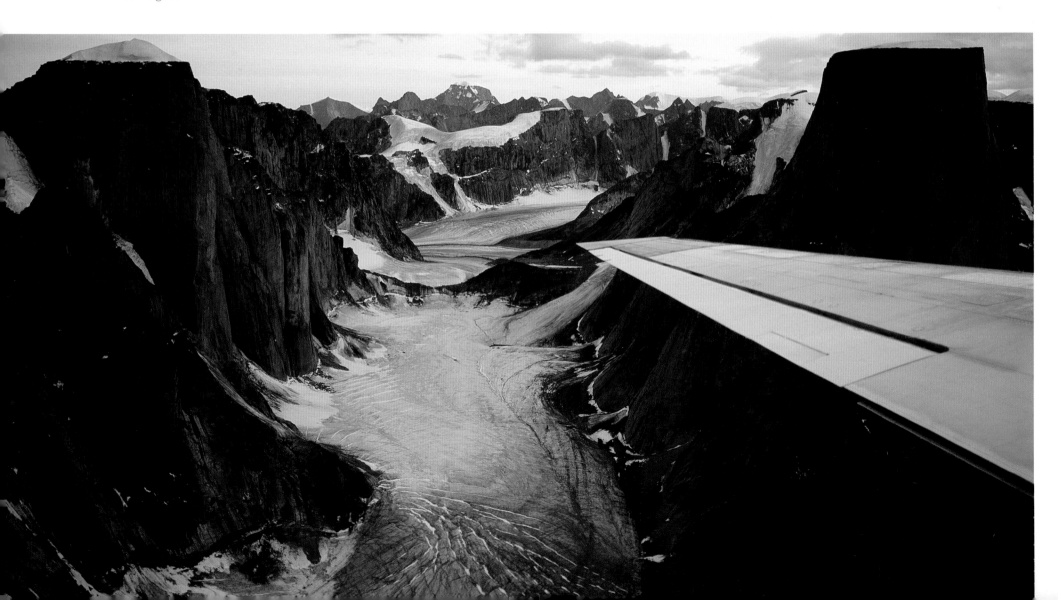

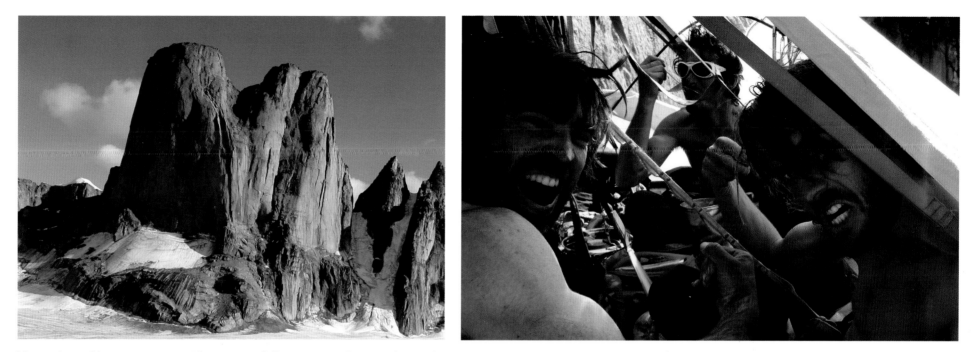

Mount Asgard has two towers with two very different micro-climates: the north tower enjoys its single hour of sunlight in the early hours of the morning (which decreases as winter approaches), while the south tower basks in around 14 hours of sunlight in the afternoon and evening. The original plan for our expedition was to completely free climb the established but normally aid-climbed Bavarian Route on the more featured south tower, taking advantage of the warmer sunlit face. However, the Belgian climbers Nico Favresse and Sean Villanueva (pictured above) also had plans to climb Asgard. They had arrived a month earlier than our expedition and were reporting record-breaking conditions with no clouds and above-average temperatures for July. ABOVE LEFT - Asgard's two towers displaying their different climatic facets of sun and shade. ABOVE RIGHT - 'Team Belgium' led by Nico Favresse and Sean Villanueva living the dream high on the south tower. These guys were *sauvage*; one of the strongest big wall climbing teams of their generation. It seemed difficult to describe them as mere mortals – perhaps they were climbing gods?

Sean Villanueva reports –
'The first 35 days we were in the park we had to endure 15 minutes of rain. Other than that we had nothing but blue skies, day and night. While on the Bavarian Route there were moments when it was too warm and sunny to climb hard, technical, crimpy sections. We were forced to hang out in our portaledge waiting for the shade! Never have we had such warm and stable conditions on an expedition. We spent 5 hours on the summit just admiring the sunrise, something that would be totally inconceivable in a place like Patagonia. However, these conditions were exceptional, and the term global warming does come to mind. The downside is that there was a lot of rock fall and avalanches, making the approaches very dangerous. As we had finished our route and were walking off the glacier, back toward civilization, big black clouds came rolling in. As Leo's team started climbing their route, all hell broke loose!

Even though we hoped for their success, it was hard to imagine that it was possible to keep climbing in those conditions.'

RIGHT - The Belgian team enjoyed unprecidented conditions on the south-west face of the south tower. The Asgard gods remained uncharacteristically calm.

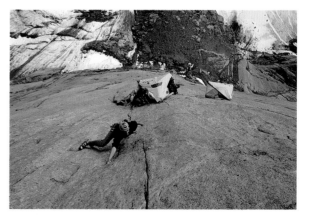

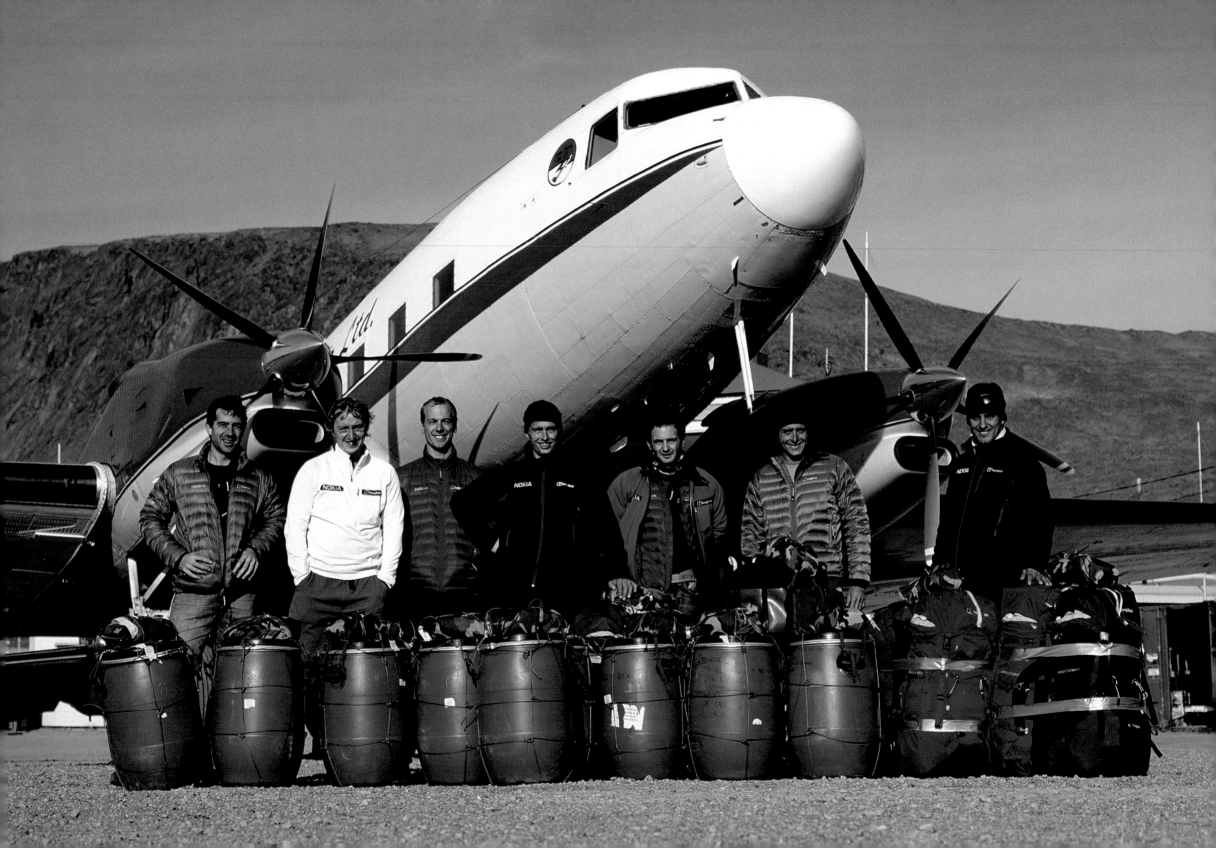

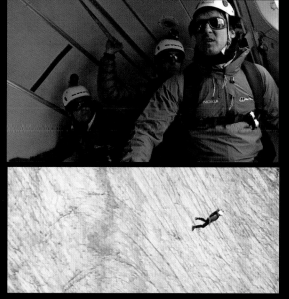

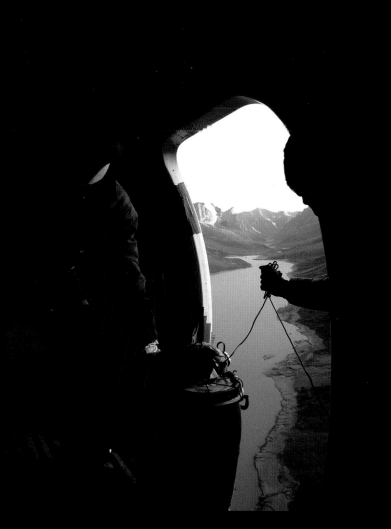

The climbing season on Mount Asgard is short; July and August are the two months that often give the best conditions. Our expedition, led by Leo Houlding, opted for August. Its original objective was to make a free climb on the south-west face. We also wanted to make a ground-breaking film about the ascent. Having read the reports of the Belgians' trip and the exceptionally benign conditions they had experienced, we feared the worst, anticipating that this happy state of affairs could not possibly hold for another month. As we flew past Asgard in our chartered DC-3 at the end of July ready to airdrop our equipment, ominous clouds gathered while we observed the Belgian team descending the Bavarian Route on the south-west face following their successful ascent.

OPPOSITE - 'Team Hollywood': Leo Houlding's Asgard expedition team and a venerable Douglas DC-3 on Pangnirtung's dirt runway, with 600 kilograms of gear waiting to be dropped at the base of Mount Asgard 50 miles away. It would have taken weeks to carry all this gear to base camp, so we leapt at the chance to charter this classic aeroplane. From left to right; the author, Ian Burton, Chris Rabone, Leo Houlding, Jason Pickles, Sean 'Stanley' Leary, Carlos Suarez. LEFT - The gear was packed in barrels, Sean 'Stanley' Leary holds the parachute release cord as they wait for the right moment to launch the first barrel. ABOVE - Climbers Carlos Suarez, Sean 'Stanley' Leary and expedition leader Leo Houlding skydived to the base of Mount Asgard once the airdrop of the food and equipment was completed.

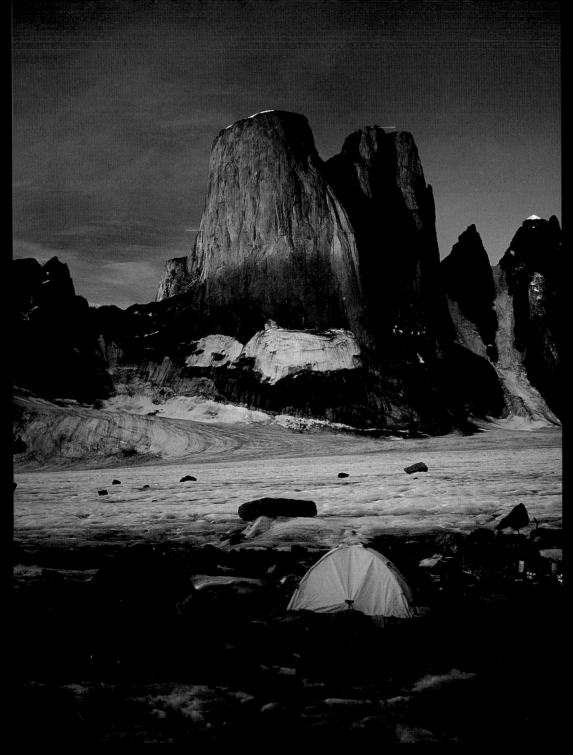

Our team spent two weeks at base camp studying the towers of Asgard in order to choose the best route. Access to the cliff this late in the season is potentially the most dangerous part of the climb, thanks to a constant freeze/thaw process which is working at its hardest in August and helping to cause enormous amounts of rock fall. Baffin does not possess the relatively stable geology of Scotland, the Lake District or even the Alps. The juggernauts of rock falling from every steep section of rock were sometimes the size of cars and occasionally even bigger. The almost constant cascade of falling rocks became a familiar background noise. In such conditions, it soon became obvious that access to the original objective on the south-west face was far too dangerous to contemplate.

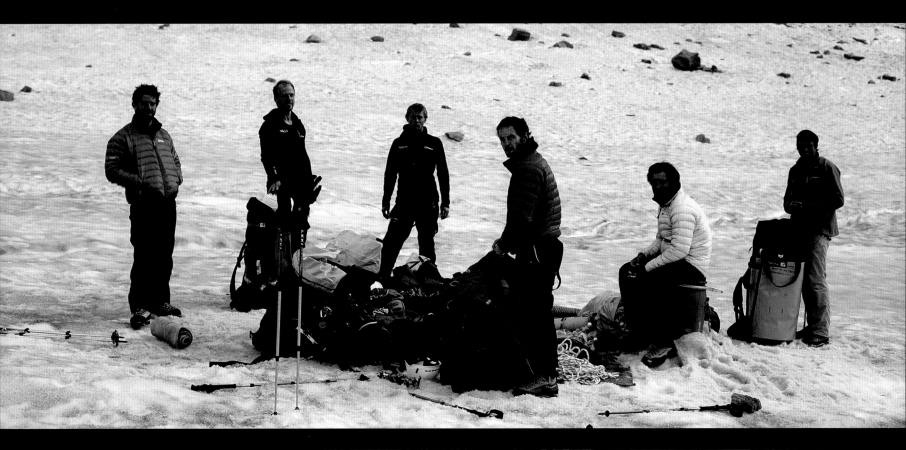

ABOVE - Locating, retrieving and organising all the equipment from the airdrop took several days. The team sort through one of the barrels. FAR RIGHT - The first few days were spent setting up base camp and studying the Asgard towers. RIGHT - The author setting up the satellite phone and solar power kit.

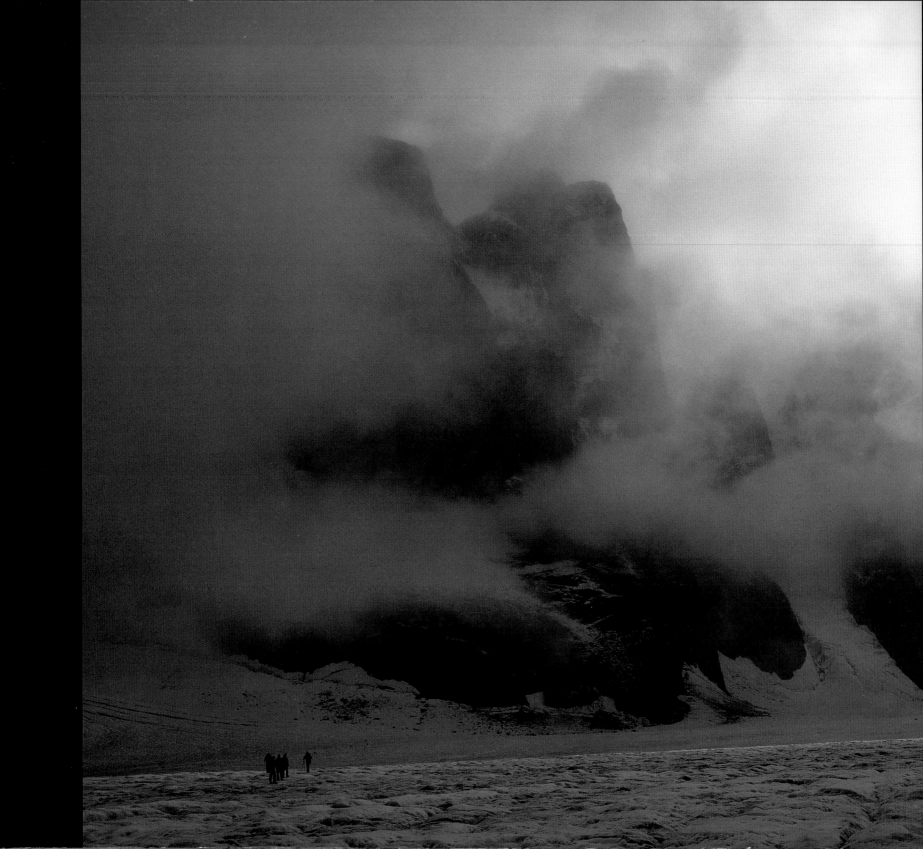

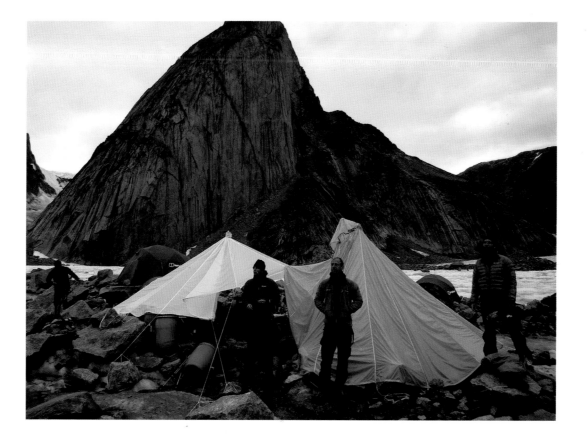

The record-breaking temperatures of July came to a sudden end once we were established on the glacier. Jason, Chris and Alastair look towards Asgard during a break in the weather. After a week or so at base camp conditions got worse and worse. The team constructed a mess tent style shelter from the parachutes used in the airdrop. OVERLEAF - A break in the low cloud cover gave the occasional photographic opportunity. The days rolled by as the team began to wonder if we would even get the chance to get on the mountain let alone make a successful ascent. Photo Ian Burton.

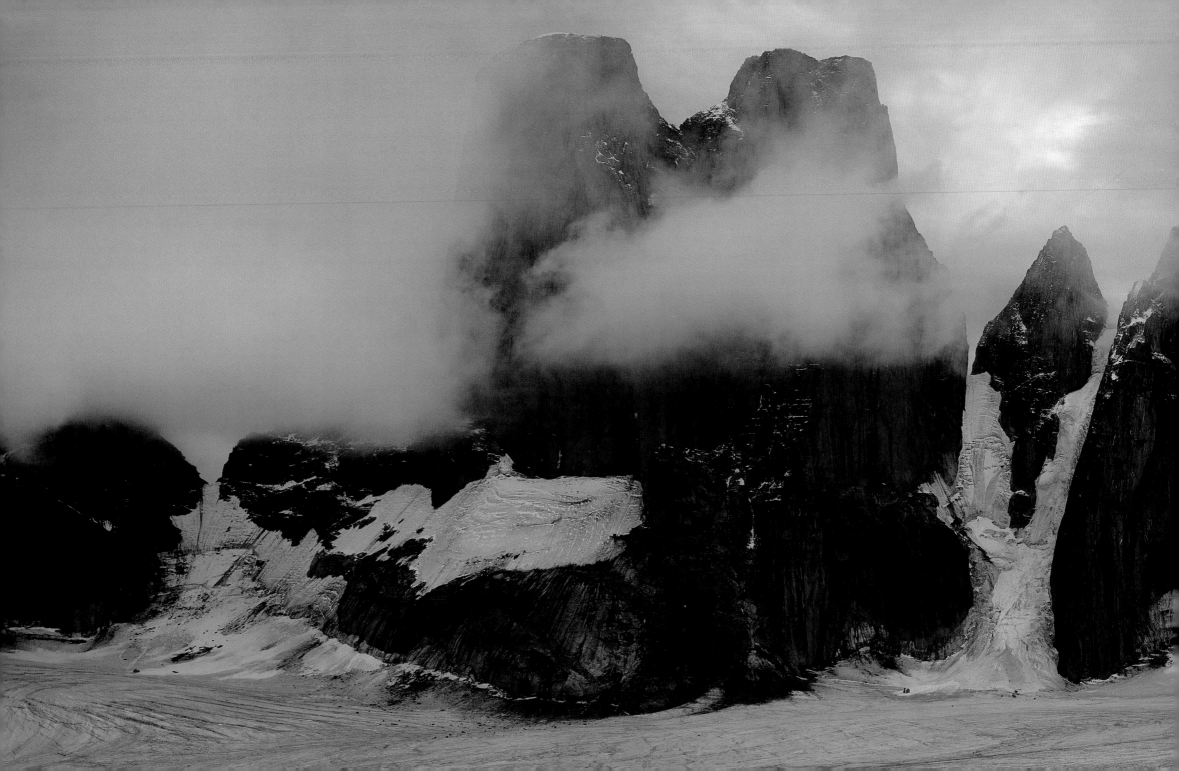

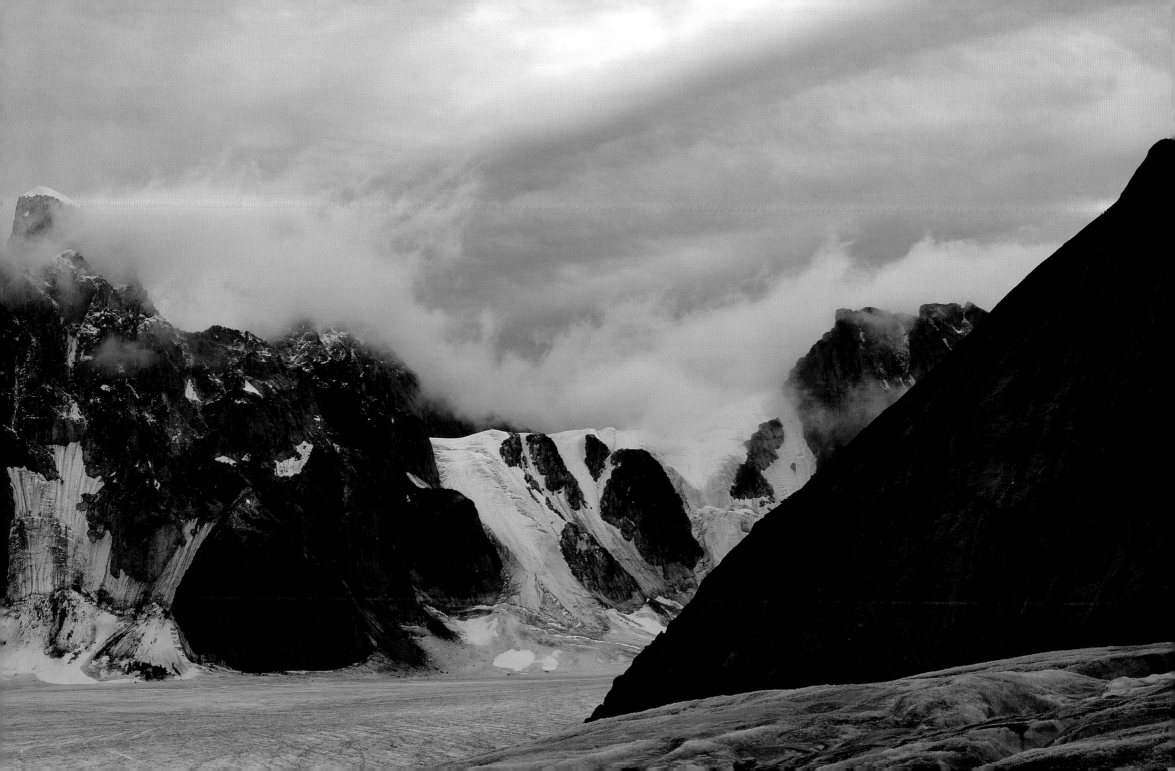

Inukshuk: *'To behave like a human'*

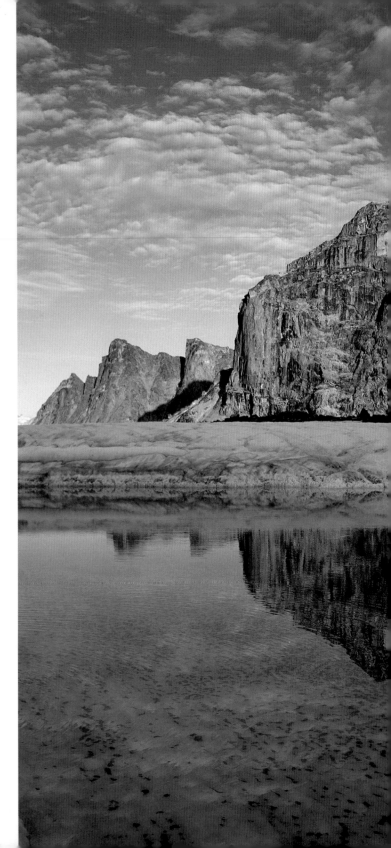

After two weeks studying Asgard's towers and several days of poor weather, the skies cleared. Based on the area with the safest access to the wall with the least rock fall the decision was made to climb a route by the name of Inukshuk. Originally climbed by a Swiss team over two seasons in 1994, Inukshuk followed a blank line straight up centre of the steep, cold north tower.

ABOVE - Leo Houlding at the base of the route prior to hauling the gear to the base of the cliff.
RIGHT - The twin towers of Asgard reflected in a glacial tarn. Inukshuk gets a rare glimpse of the sun.

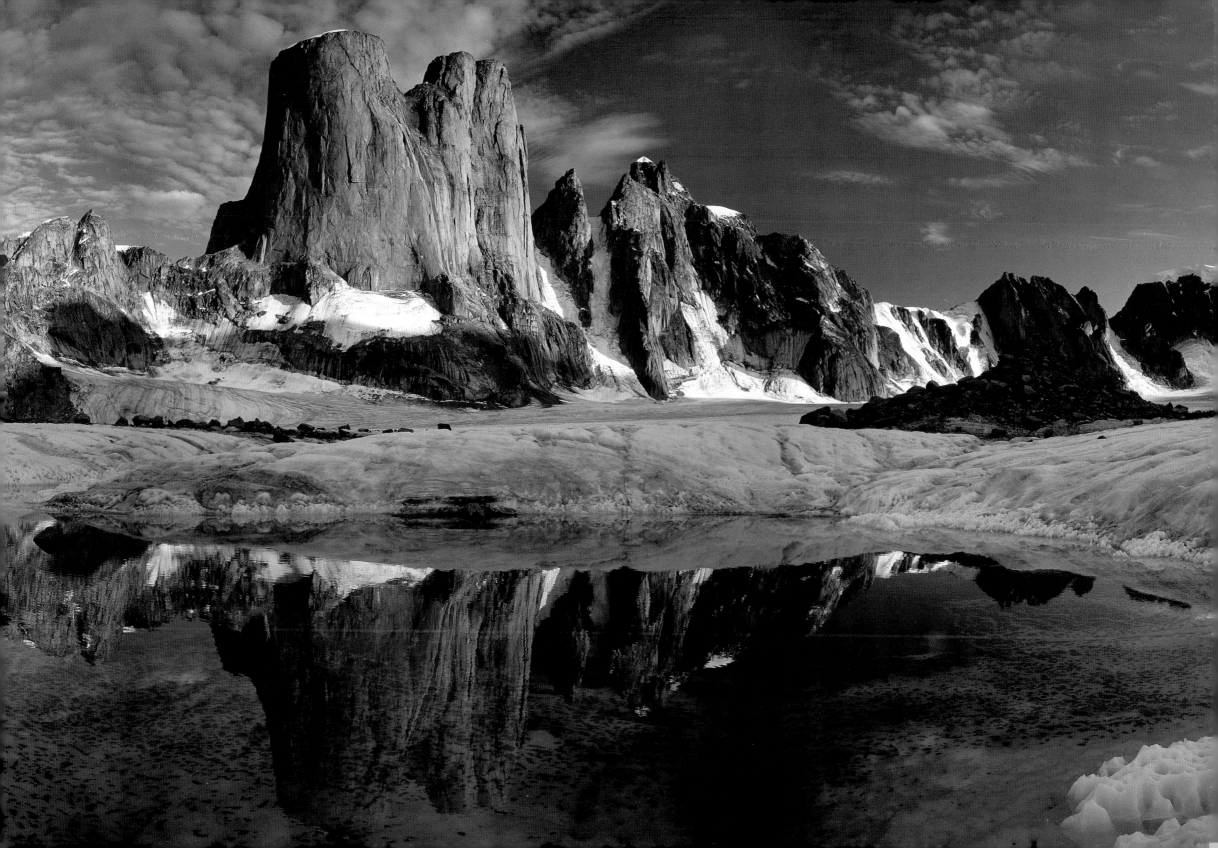

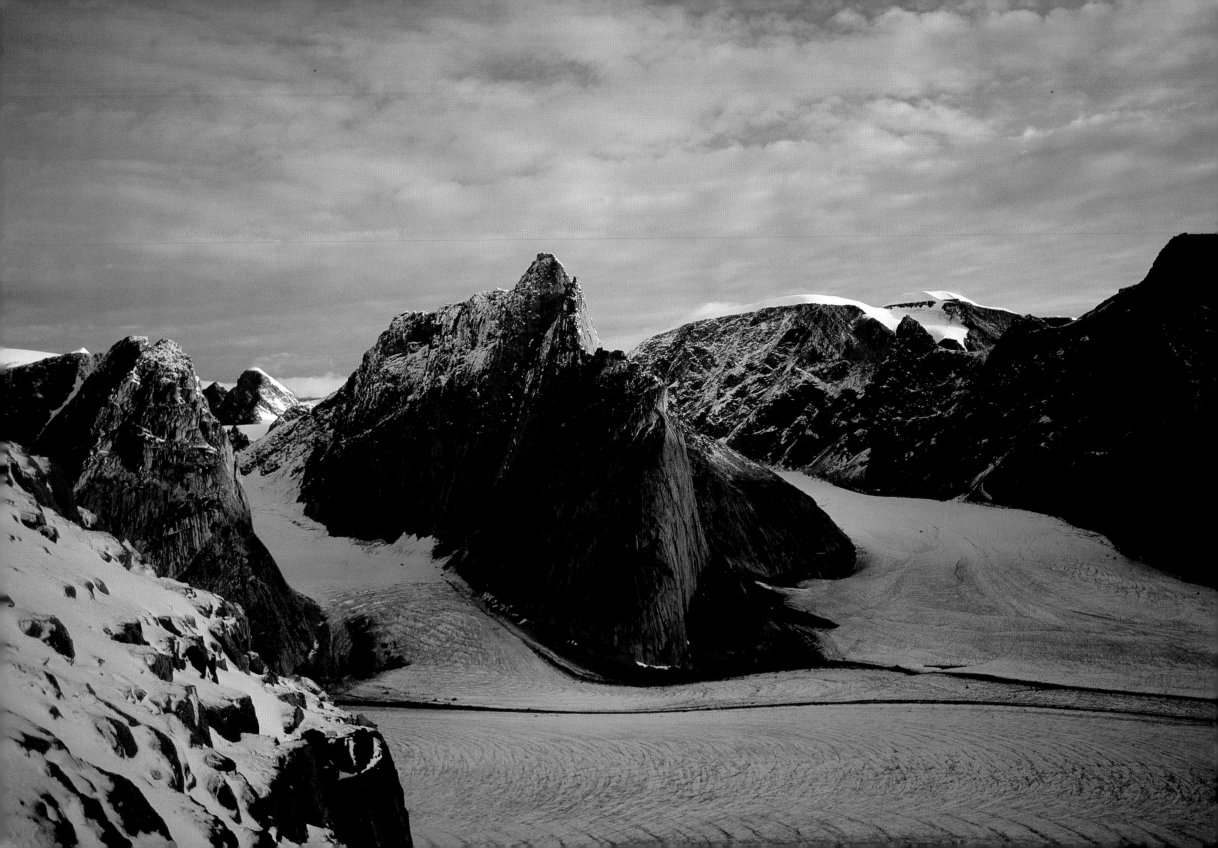

Hauling the gear was the most dangerous part of the climb. The low angle of the approach meant that the team were in the firing line from all the loose rock above and due to the unusually warm weather prior to our arrival the slope was in a very unstable condition.

OPPOSITE - Sunrise view from the base of the wall across the Turner Glacier to Mount Loki, base camp 300 metres below. It had needed a huge effort and massive logistical operation just to reach the base of the climb. However the team were now in a good position and expected to reach the summit in five to seven days.

RIGHT - The team is established in porta-ledges at the base of the route. From such an airy vantage point, peering straight up the steep and blank section of Mount Asgard's north tower felt acutely intimidating.

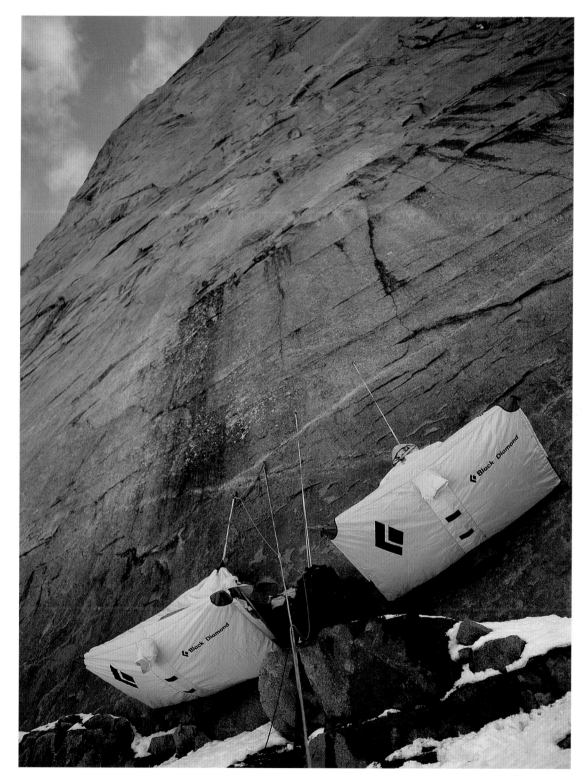

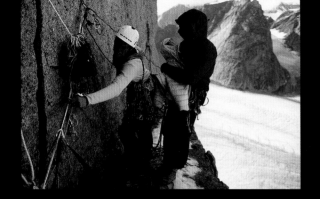
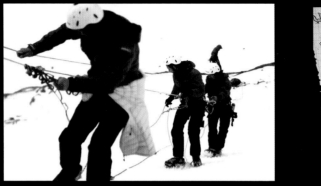
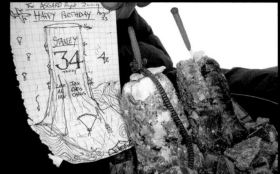

LEFT TO RIGHT - Leo and Stanley on the ledge that was to become our temporary home, preparing to tackle the fourth pitch of the route 300 metres above the glacier. Leo, Chris and Jason during the epic 24-hour haul to get all the equipment to the base of the route. During the ascent it was Stanley's birthday, and the team produced an Asgard-style birthday cake from two flapjacks, including pieces of 'chocolate loose rock' at its base!

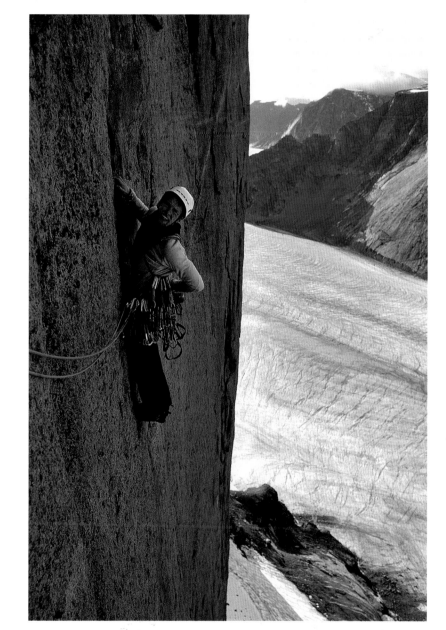

LEFT - Leo Houlding steps from the camp ledge on to an exposed section of the wall. Leo is free climbing, ascending using only his hands and feet and using climbing protection equipment and ropes solely as a safeguard in case of a fall. The route Inukshuk was originally climbed in a different style, largely by aid climbing where the climbing equipment itself is used to help ease the ascent rather than the more difficult and 'purer' approach of climbing the rock with your bare hands.

Leo's ambition for the trip was to make the first 'free ascent' (each pitch climbed in the free style without resting or pulling on the climbing gear).

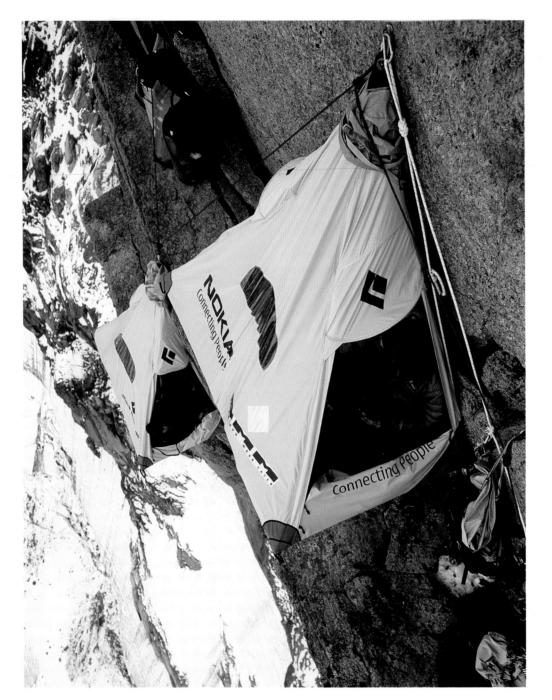

Three days after the haul to the base of the cliff the team was established around 150 metres up the wall. The small ledge seen on the right enormously increased the quality of life on the wall. The simple act of being able to step out of the portaledges and take a few steps made keeping warm and organising equipment or food a much easier task compared to a completely free hanging camp.

RIGHT - Leo opts to bivouac on the ledge – good leadership captain!

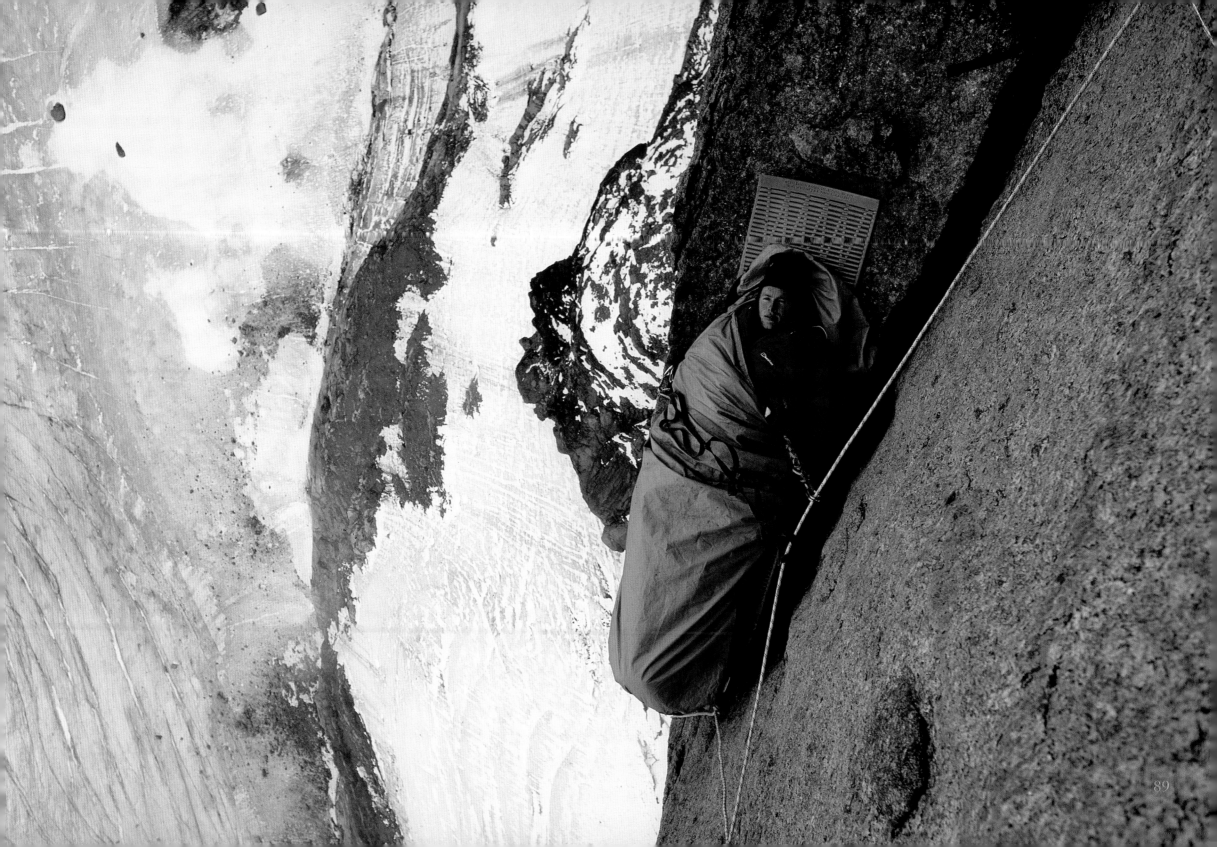

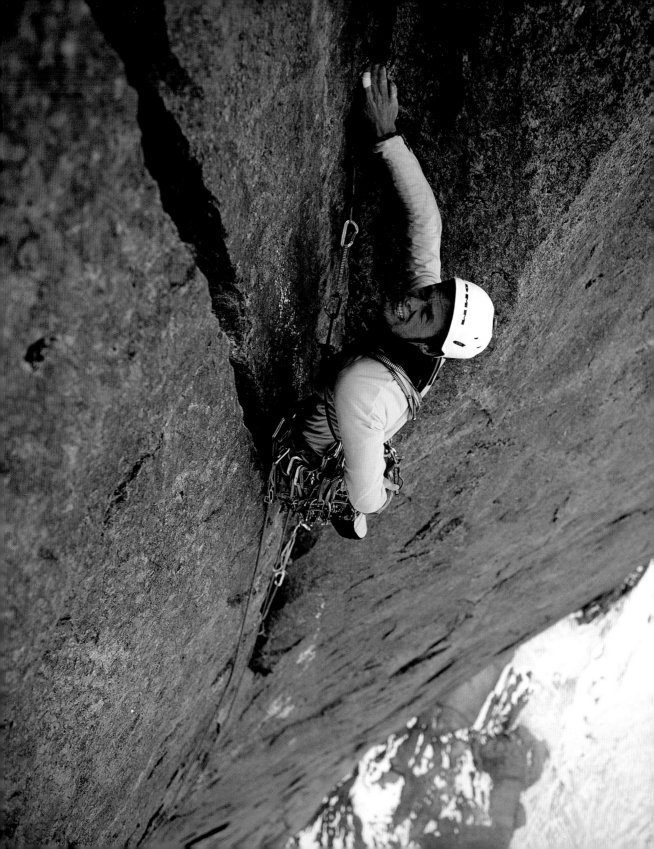

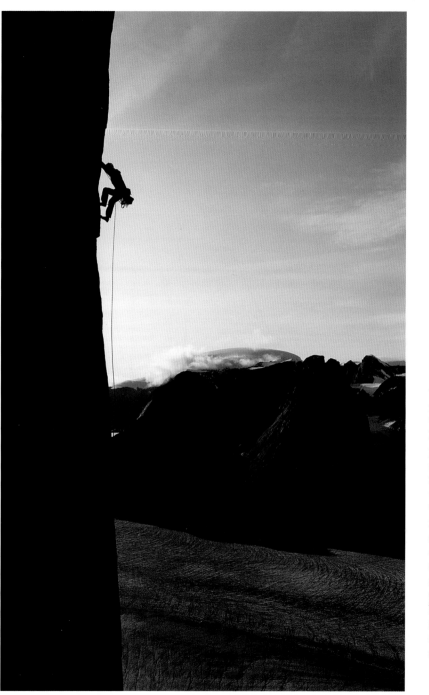

'It can't be much above freezing right now – I know I'm not!' This was the pronouncement of Leo having completed climbing this pitch. 'The good news is it's really featured rock; the bad news is, it's much steeper than it looks. I don't think it'll go free.' Leo suspected the extreme cold might prove too much of a challenge to allow the entire route to be climbed free, despite the first four pitches being accomplished in this demanding style. However the next two pitches were much steeper and blanker. OPPOSITE AND LEFT - Leo free climbs the fourth pitch of Inukshuk in less than ideal conditions (E5 6a).

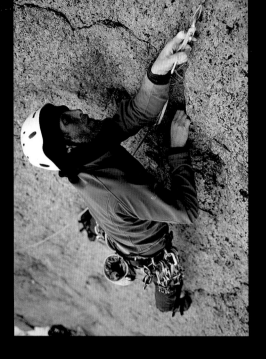

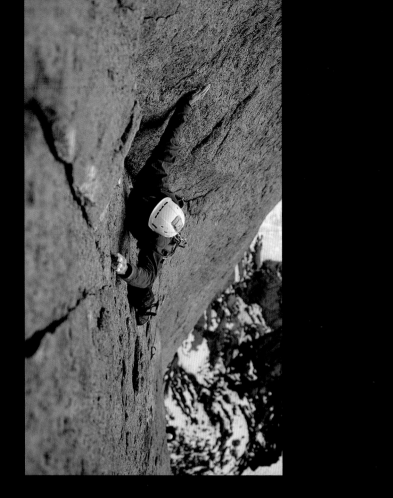

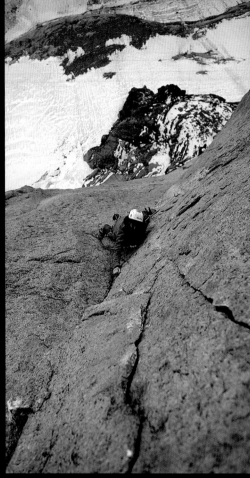

Stanley Leary on the much steeper and blanker middle section of the north face. Before attempting to free climb the pitch Stanley aid climbed the pitch to fix a rope in order to practise the free climbing moves. The photographer also used this rope to climb the pitch before pulling the rope out of shot in order to capture these dramatic images.

Stanley first attempted to 'free' this pitch in freezing conditions out of sheer desperation to achieve some upward momentum having endured many days of poor weather. In the plummeting evening temperatures, with numb hands and feet and having taken several falls, Stanley eventually made a successful free climb of the pitch the following day.

This section, at a grade of E6 6b proved to be the hardest the team would free climb on the whole route. As the weather deteriorated and temperatures lowered, simply surviving the conditions to reach the top of the mountain became the objective, overriding the style of ascent.

OVERLEAF - Stanley aid climbs high on the north face. Aid climbing involves standing in slings attached to climbing gear placed in cracks in the rock, as opposed to using your hands and feet on the rock to make upward progress.

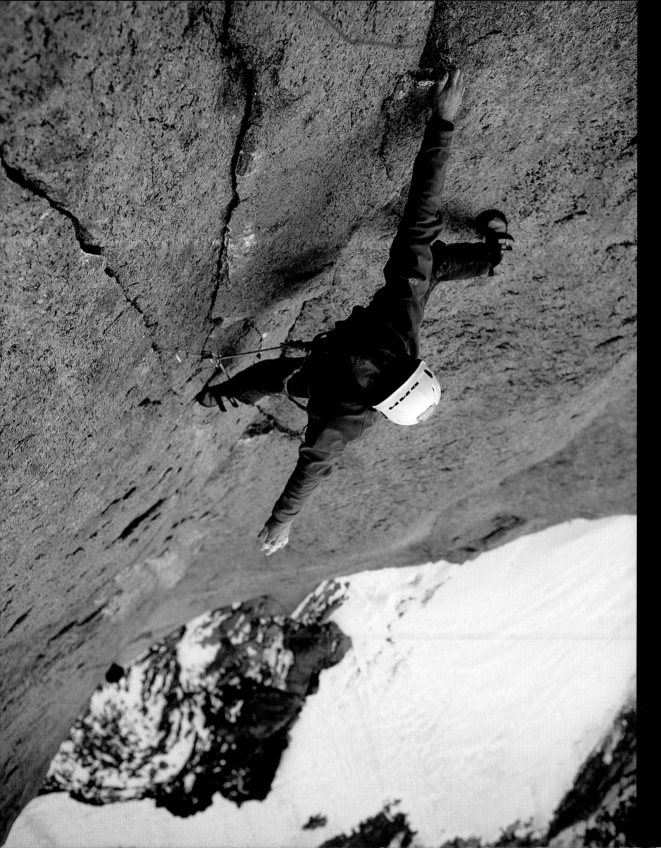

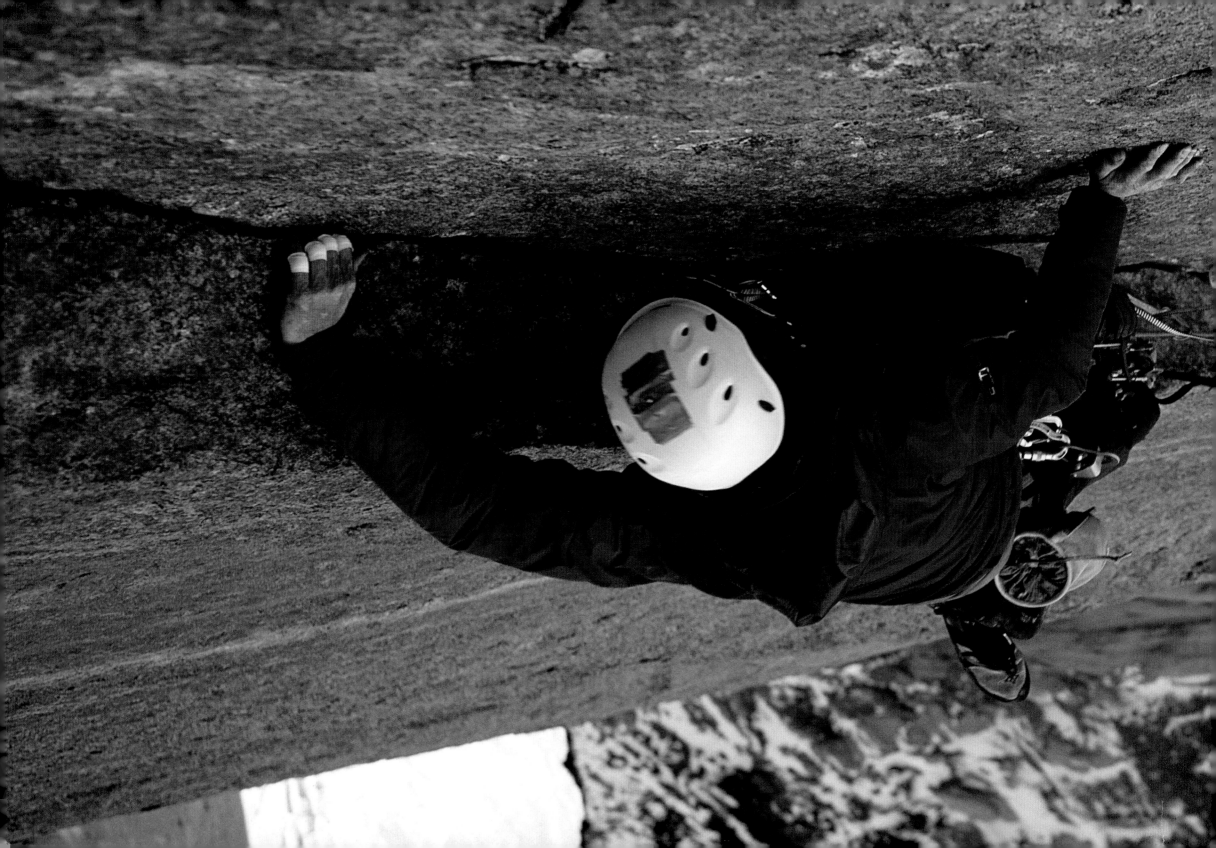

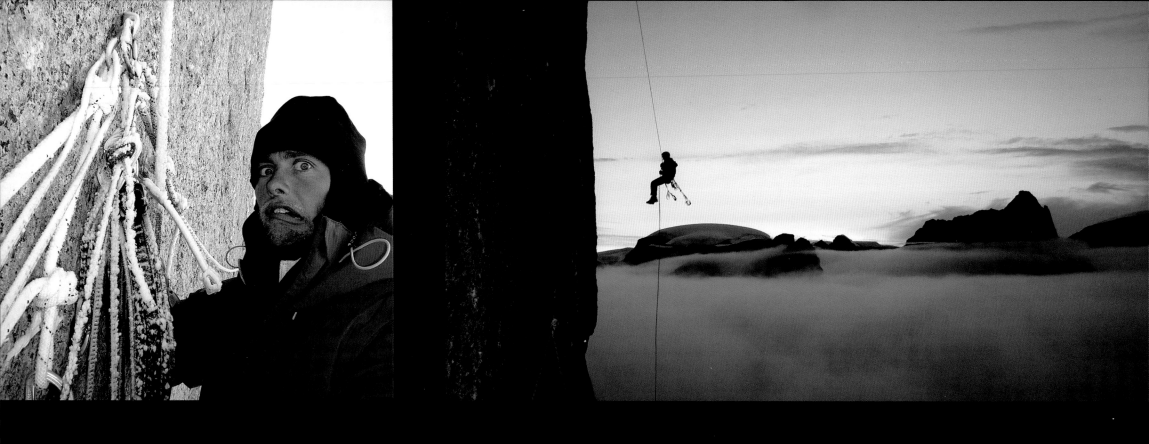

Temperatures plunged, the wind blew and the team suddenly encountered full winter conditions. For a week a cruelly suffocating cloud clung to the north face, covering everything in an inch of ice. ABOVE LEFT - Leo examines the iced ropes and concludes that descent might be the only option. ABOVE RIGHT - Alastair abseiling back to the wall camp having filmed Stanley attempting to free the pitch seen on pages 92 & 93. Photo Leo Houlding.

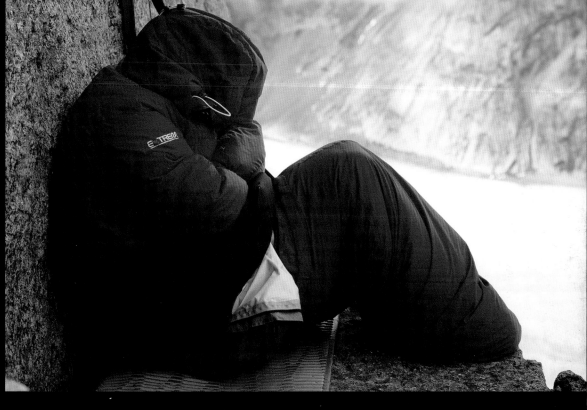

ABOVE LEFT - Looking down the ice-covered ropes to the lower portaledge. After nine days on the wall the team considered retreat might be inevitable unless there was a dramatic improvement in conditions. ABOVE RIGHT - Leo Houlding sits out the freezing conditions and realises his dream of making a free ascent of the route is over. The team's focus now switched to simply getting to the top of the route, but after such a long time on the wall, with painfully slow upward progress and ever deteriorating conditions, even achieving this goal was starting to look impossible.

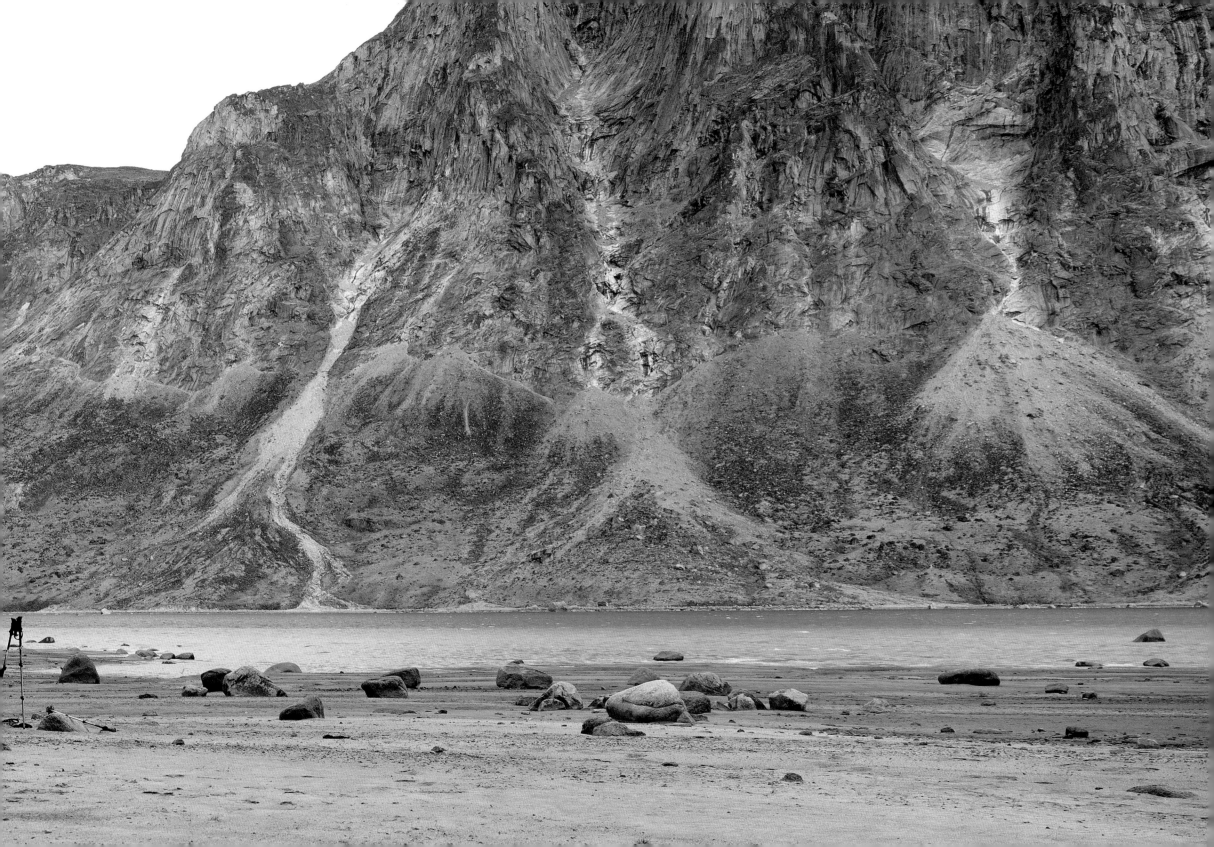

Leo Houlding
Climber & Expedition Leader

Leo's CV is hard to beat, from climber to all round adventurer, he has done it all. Started climbing at the age of ten, began big wall climbing not many years after that.

He said - 'Well, it is Asgard, home of the gods.'
We said - 'Brilliant leader and climber, I'd let him take me anywhere.'

The baby of the team, but also the leader – there's something wrong about that.

Sean 'Stanley' Learey
Climber

The worlds nicest psycho. The unsung hero of modern climbing in North America. He joined Leo in climbing El Capitan and Half Dome in a single 24-hour record-breaking push. 'Stanley' is partial to using DIY tools whilst climbing, hence his nickname.

He said - 'B****h, f**K, crack, ****.'
We said - 'Keep his caffeine levels up and anything is possible.'

When push came to shove Stanley would pull it off and get us up there.

Carlos Suarez
Climber

Spain's best all round climber, base jumper, wing-suiter, and a really cool guy. Carlos slept a lot more than any other team member, by a large margin.

He said - 'The north face?'
We said - 'Siestas should be banned from expeditions.'

Carlos' hard work whilst at base camp ensured most of the work was done once the wall team returned.

Jason Pickles
Rigger

'Britain's manliest man' (official) and Leo's best mate. He revels in carrying a heavy pack, hard work and suffering. However, the less said about the river crossings the better. Cold water is not Jason's thing.

He said - *'I couldn't make it to the ledge so I had to go in my pants. It's okay, I got a knife and cut my tights off.'*
We said - *'Should have his own TV series.'*

Jason's inexstinguishable spirit and climbing skills came to the fore once Leo had injured his fingers. Jason 'manned up' and got the job done.

Chris Rabone
Rigger

Chris is a very tough man, and he always has a smile on his face. The handyman of the expedition, he could fix everything except the weather. He was a little too dependant on his mobile phone however, which contrary to popular belief will not save you from an Arctic big wall.

He said - *'No.'*
We said - *'Have you ever climbed a big wall before?'*

Chris was orginally part of the base camp team, however, like Jason, when the time came Chris couldn't help but man up to the situation.

Alastair Lee
Film maker

Alastair is the architect of modern adventure filmmaking, and self-taught. The film from this trip *The Asgard Project* won everything going and was broadcast on TV around the world. A genius at filmmaking maybe, just dont sit next to him on a boat, or a plane, or anything else that moves for that matter.

He said - *'That sounds near impossible, when are we going?'*
We said - *'Clear winner of Baffin's best beard 2009.'*

First worked with Leo in his previous climbing film *On Sight*. A drop in TV work led Leo to turn to Al's filmmaking skills and we're ever so glad he did.

Ian Burton
Cameraman

Before this trip Ian had never set foot outside of his mum's house so the Turner Glacier was quite a change in scenery. Always energetic and movtivated to get the camera out in the most adverse of situations.

He said - *'All I can hear is some very stange noises.'* (Having been left alone at base camp for almost an hour.)
We said - *'It's okay – death via Polar bear can be painful but should be quick, unless you are horrifically injured.'*

Ian's contribution to the photography in this book and his superb timelaspe photography for the film was an integral part of its success.

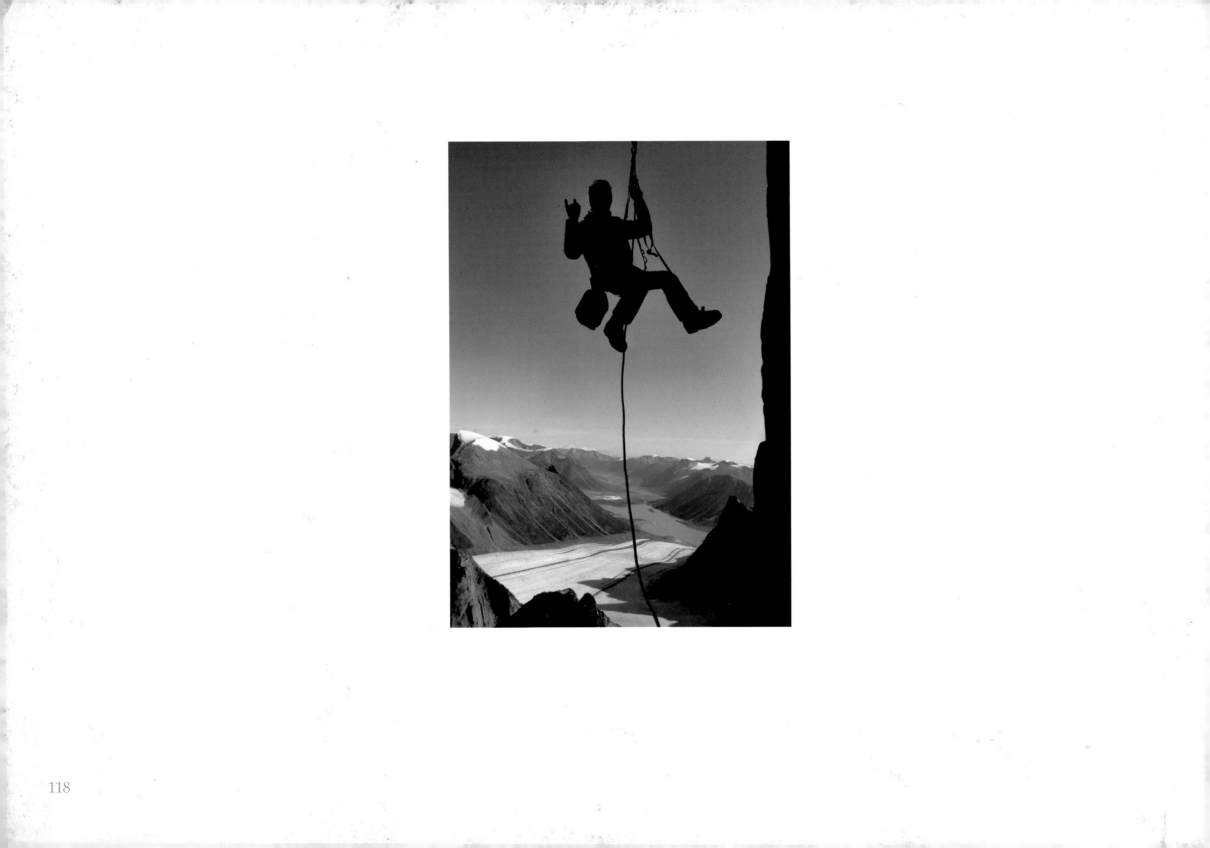

First of all special thanks to the Asgard team – without their hard work, planning and perseverance I wouldn't have taken any of these pictures, so thanks guys, I'll get you a beer for that one! Leo Houlding, Jason Pickles, Stanley Leary, Carlos Suarez, Chris Rabone and Ian Burton. Special thanks to Ian Burton for his earlier work in developing this book with some good ideas for both the text and layout. Also thanks for all Ian's hard work on the trip in assisting me with the kit involved in many of these photographs and for being such a willing learner so he could use the large format camera whilst I was on the wall. Thanks also go out to Andrew Dunn of Frances Lincoln, Richard and Jayne Davies of Dysons Arts, Colin Wells and David Halsted for his excellent sketch maps.

This expedition was possible due to the support of - Berghaus, Nokia, DMM, Linde & Werdelin Watches, Adidas Eyewear, Brunton Solar Equipment, Gerber Knives. And thanks to - Kendal Jack Smiths, Be Well Foods, Lakes Climber Ambleside, First Ascent, Lyon Equipment, BAC Outdoor Leisure, Sony UK Ltd., Riglos Climbers Refuge, Mick Ryan and Alan James of ukclimbing.com.

Special thanks also go to - Delia and Billy of Parks Canada, Charlie our outfitter, Robbie Pecnik, Sarah Wilson – a personal thanks, Jason Singer Smith, Theshold Sports, Pete Swan our parachute rigger, Kenn Borek Air Ltd. DC-3T C-GJKB crew: Captain Robert Linn, First Officer Louis-Eric Belanger, Flight Engineer Dennis Hogewoning, Loadmaster Colin Cirtwill.

Airdrops and skydiving are prohibited in the Asgard area, special permission must be granted.

LEFT - Author and photographer Alastair Lee strikes a pose for the camera on the final ascent of Mount Asgard. Photo Leo Houlding.
ABOVE - Alastair in action with his medium format camera on the wall; a Fuji 6X17 panoramic camera was used on the ground.
OVERLEAF - Looking up the Turner Glacier on route to Mount Asgard. The foot of the mountain can be seen on the left, Mount Loki on the right.